THE
Archive Photographs
SERIES
SOUTHPORT

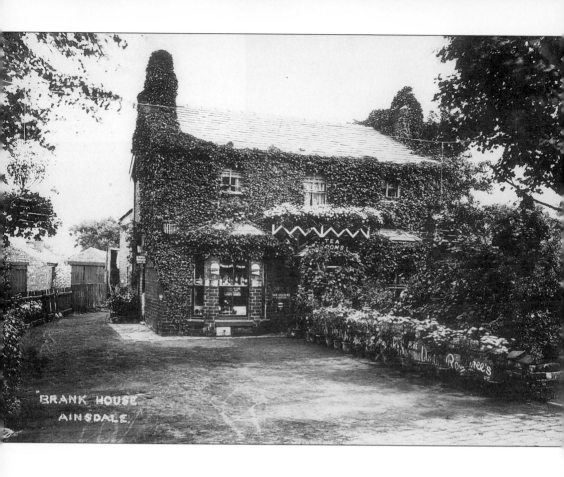

To Joanne, Miranda and Gary

THE
Archive Photographs
SERIES

SOUTHPORT

Compiled by
Ian Simpson

CHALFORD

First published 1996
Copyright © Ian Simpson, 1996

The Chalford Publishing Company
St Mary's Mill, Chalford,
Stroud, Gloucestershire, GL6 8NX

ISBN 0 7524 0665 5

Typesetting and origination by
The Chalford Publishing Company
Printed in Great Britain by
Redwood Books, Trowbridge

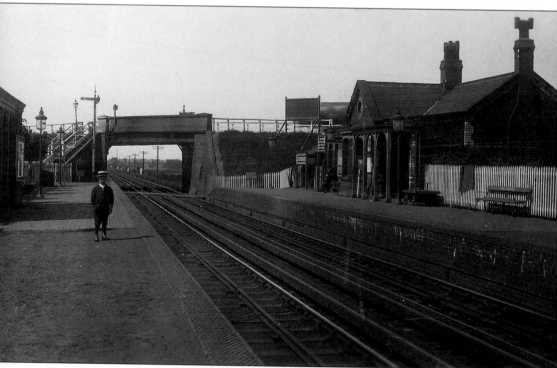

Crossens station, looking towards Southport, 1912.

Contents

Acknowledgements

Special thanks for support, information and assistance are due to
Michael Braham, Ethel Goulder, Brian Heaton, Richard Howard, Brian Legan,
Alice Newton, Pat O'Brien, Margaret Rimmer
and my parents, Eric and Dorothy Simpson.

Introduction

'The appearance of this place is truly romantic, and fully compensates for the labour of traversing through the deep sand ... the white cottages exhibit a pleasing inland picture ... I would strongly recommend all these to be washed over a cream colour ... When the sun shines, the glaring white is extremely distressing and injurious to the eyes ... It is impossible to correct the sparkling of the sand, but there is certainly no necessity of increasing the sensation this causes, painful as it sometimes is, even to those who are blessed with strong vision ... The breaking of the surf over the beach, when the tide flows with a high westerly wind, is awfully grand.'

Thus wrote Thomas Kirkland Glazebrook in his *Guide to South-Port* published in 1809. If it was possible to assemble all the literature relating to Southport since that time it would make an impressive pile. The accumulation of published work normally associated with a town the size of Southport – the histories, municipal records, publications by local organisations, newspapers and so forth – has been significantly added to here because of the town's development as a resort. Guides, handbooks and commentaries of every description have proliferated over the last 200 years, to such an extent that researchers have little difficulty in acquiring the knowledge they seek.

The same cannot be said about photographic images. When Dr. Miles Barton dashed his celebrated bottle of wine in 1798 and gave the hamlet of South Hawes the name of South Port, photography was not available. Although scientific advances in the second half of the nineteenth century enabled the camera to become an increasingly common sight on the streets of Britain, the

fragile nature of early photographs has meant that their survival rate has been relatively low. In Southport's case, the vast majority of images that have survived, and with which people are familiar, consist of the popular seaside and tourist views which appeared on the resort's picture postcards in the early 1900's. It is especially pleasing, therefore, to be able to present in this book some of the scarcer pictures of the town and its people.

In preparing this compilation, I have tried to provide readers with an opportunity to examine a broad and interesting range of photographs that relate to the whole of Southport, from Crossens to Woodvale, whilst also presenting a balanced view of the town, bearing in mind its status as a community as well as a resort. Accordingly, the pages which follow contain interest not only in terms of places, but also in terms of some of the people who have, to a greater or lesser degree, left an impression on their community.

The dividing of the book into districts encourages the reader to wander, as it were, through the borough from north to south, and to enjoy some of the sights of old Southport without having to leave the armchair. The pictures span the greater part of a hundred years and inevitably some of them will evoke distant memories for older residents, whilst those without the memories but with some imagination will be able to 'visit' those earlier times through these evocative images. Such is the power of old photographs that we can all enjoy this wonderful illusion of time travelling!

The impression given by a collection of old photographs of life in the past is, of course, only part of a story. Rarely did photographers record, for example, the poor and destitute, or at least not when they were looking under privileged. Most images were created to give a good impression of a town and its people, especially when they were to be included on a postcard view. The real past, though, is made up of troubles and sorrows as well as good times. The years immediately preceding the First World War are considered by many to be the period when Southport was at its zenith as a health resort, but one needs to look no further than the local court and public health records to realise that Southport at this time had its quota of misery. Begging, drunkenness, prostitution, vagrancy, indecency, squalor and so on were all part of everyday life. Behind the affluence and merriment that one normally associates with the town was a layer of wretchedness that, as in most other towns, was largely hidden from view. One should, perhaps, bear this in mind when looking through these photographs.

If readers find just a modicum of interest, pleasure or fascination from these pages, I shall be delighted.

Ian Simpson
Larkfield Lane
Marshside
Southport
October 1996

One

Crossens

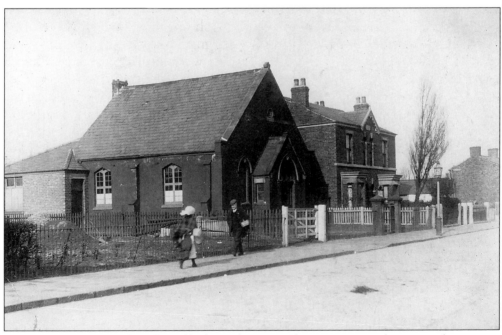

Primitive Methodist Chapel, Rufford Road, 1910. The strong attendances at the cottage meetings of the Crossens Primitive Methodists in the mid-nineteenth century resulted in a decision being taken, in 1865, to build a chapel. A site having been secured on the high road, the corner stone was laid on 22 March 1866. The building was erected from the plans of William Hodge, at a cost of £200. It was known as Providence Chapel, and standing alongside to the right in the photograph is Providence Place.

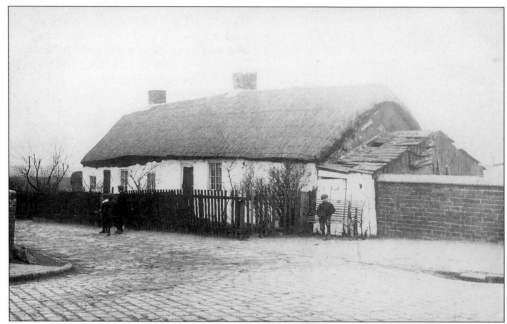

Cottage, Dock Lane, *c.* 1907. This white-washed, thatched cottage was typical of many of the primitive dwellings around Crossens, Churchtown and Marshside. It stood next to the marshes at the head of Rufford Road, within a few yards of the present roundabout near to the Plough Hotel. It was demolished to make way for the building of Preston New Road, which opened in 1924.

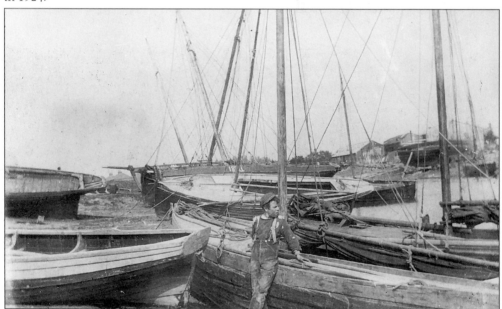

Boats in the Crossens sluice, *c.* 1900. Some idea of the scale of the Crossens fishing industry, and its boatbuilding activities, can be gained from this scene of Crossens Pool. Scores of shallow water sailing trawlers, thirty to forty feet in length, were built here and at Marshside. In 1900, the navigability of the channels was not the major issue it was to become, but silting during the following decades swiftly brought the industry to an end.

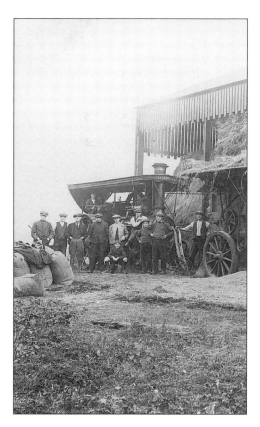

Workers at Plough Farm, *c*. 1920. The men pause for a moment from their threshing labours. Plough Farm was situated in Water Lane, between the Plough Hotel and Hey Farm, its fields extending back towards St. John's vicarage and the Three Pools waterway. During the nineteenth and early part of the twentieth century the Crossens community was very much based on agriculture, with numerous references in the school log books to children being unable to attend school because they were needed to help in the fields at sowing and harvesting time.

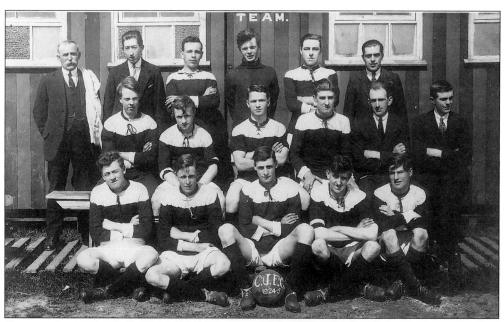

Crossens Junior Football Club, 1924-25 season. The team and officials are seen outside their pavilion in New Lane.

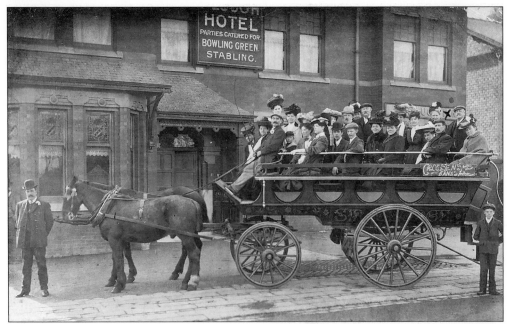

Coaching party, Plough Hotel, November 1907. Pleasure trips by horse-drawn carriage to outlying areas such as Crossens, Banks, Ormskirk and Halsall were popular around the turn of the century. They were not restricted to the summer months – these excursionists are taking the air on a fine late autumn day. The carriages were often individually named, this one being *Sir George*.

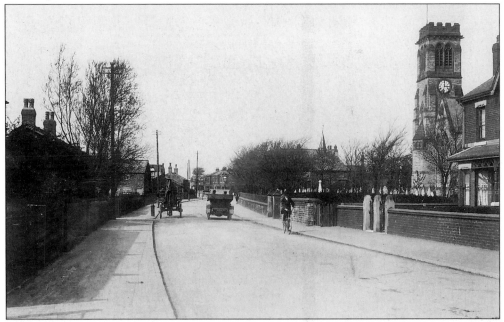

Rufford Road, *c.* 1910. An early motor car on its way towards Banks is caught passing over the Old Pool, which flowed out of the lake in the Botanic Gardens, Churchtown, under Rufford Road, and on to the Three Pools waterway. Beyond the graveyard of St. John's church can be seen the spire of the church school.

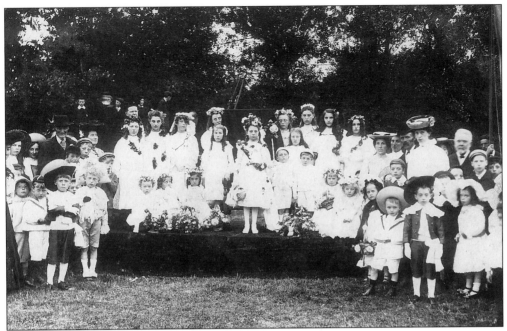

Rose Queen Festival, Glebe Lands, July 1906. Jennie Wareing takes centre stage on the occasion of her crowning as Crossens' first ever Rose Queen. The ceremony, performed by Lady Pilkington, took place on the second day of the Horticultural Show. Unfortunately a heavy shower right at the end spoiled what was otherwise a very enjoyable day for the children.

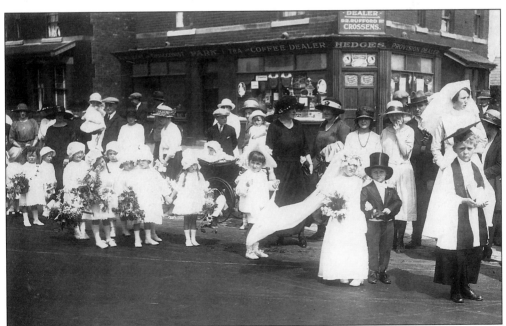

Procession, Rose Queen Festival, Rufford Road, c. 1925. By this time the festival was well established, and included a village wedding, first introduced in 1910. Here, the parson, bride, groom and retinue are seen outside John Hedges' grocer's shop on the corner of New Lane.

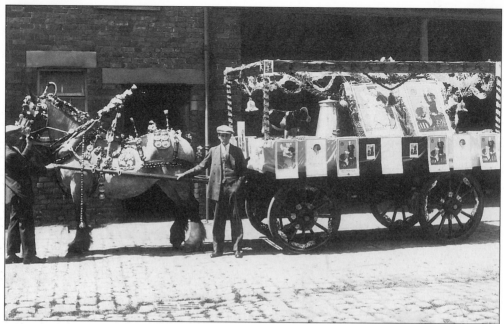

Crossens Festival float, Holly Farm, New Lane, *c.* 1925. The magnificently decorated working horse and float are ready to take their place in the procession. The advertisements proclaim the virtues of drinking fresh milk.

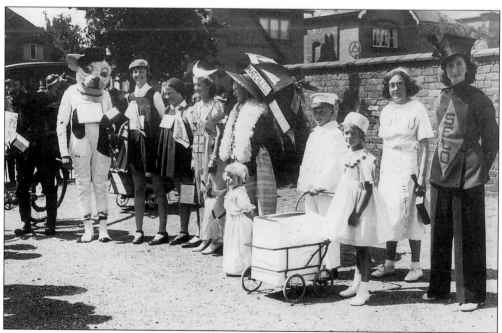

Crossens Festival, 1939. Just weeks before the start of the Second World War, the youngsters who line up in the school yard feature a splendid dog costume worn by Dick Howard, complete with Chaplin-moustache and slick hairstyle, suitably labelled 'Adolf, German Terrier'. Smiling radiantly next to Adolf is Margaret Gildert. Molly Wilkinson holds her 'Matchless' umbrella, while sister Eugenie stands on the extreme right.

14

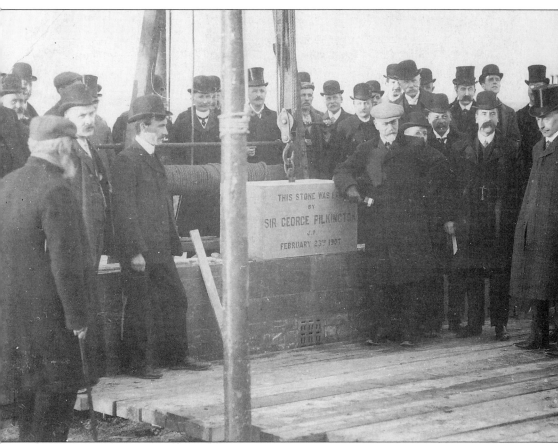

Laying the foundation stone, Vulcan Motor Works, 1907. Sir George Pilkington, who became the first Member of Parliament for the Southport Division in 1885, performs the stone-laying ceremony on Saturday 23 February. During the following twenty years or so, cars, lorries, buses and even aeroplanes were assembled here, but car production ceased in 1928. Tilling Stevens took over the company in 1933, and transferred the rest of the business to their Victoria Works in Maidstone in 1936. Brockhouse Engineering moved into the premises two years later.

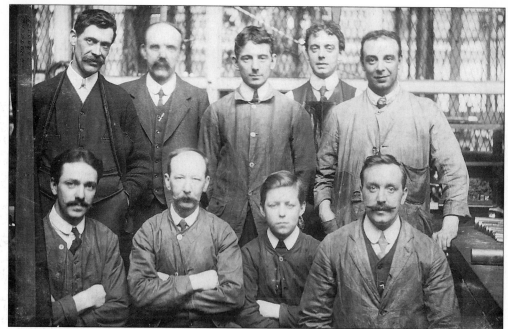

Tool Room staff, Vulcan Motor Works, 1914. Self-esteem emanates from the faces of, back row, left to right: Edward Wood, Frank Hall, Lawrence Shackleton, A. Bailey, W. Meakin; front row: Charles Tonge, J. Parkinson, Charles Bailey and Newton Leaity.

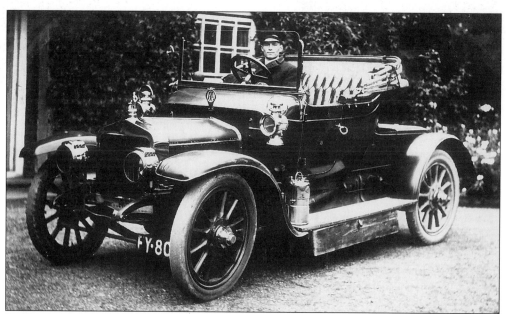

Vulcan motor car, c. 1912. This impressive convertible was the kind of car which made Vulcan's employees understandably proud of their efforts. The Roman god of fire and metalwork was represented as a blacksmith at the forge when the company introduced radiator mascots in about 1910.

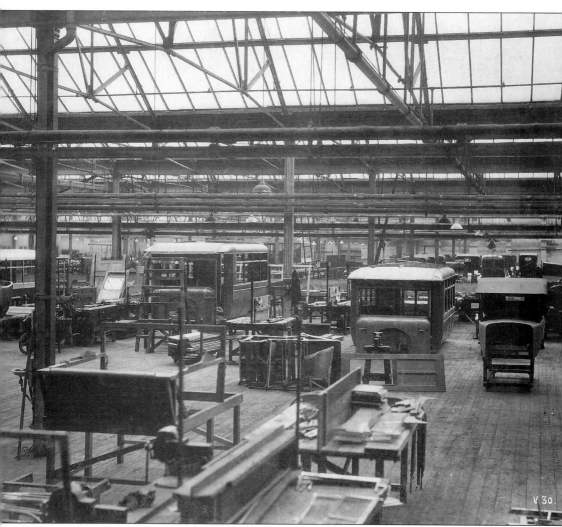

Vulcan Motors workshop, *c. 1924.* This detailed photograph gives an excellent impression of what conditions were like in Southport's largest workshop. The 1920's saw Vulcan build the first single deck buses for Southport Corporation, and the three under construction here were of that type. The one on the extreme left carries the Corporation livery.

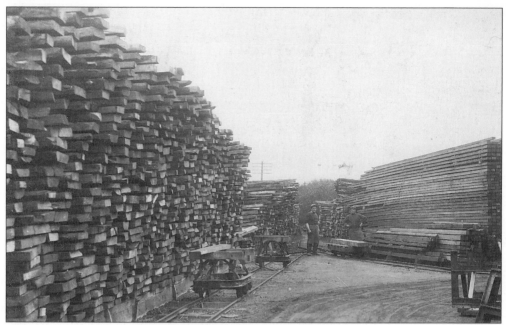

Vulcan Motors yard, *c.* 1924. The huge amount of wood needed to build Vulcan vehicles is indicated by the stacks of timber piled high outside the factory.

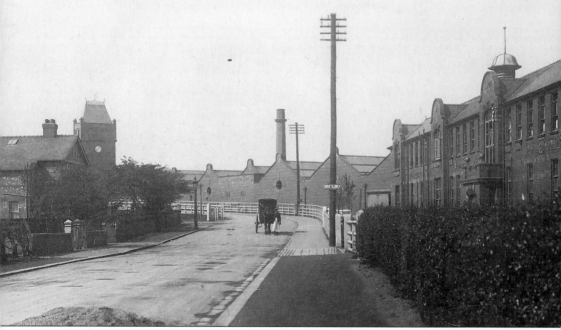

Vulcan Motor Works, Rufford Road, 1915. When factory building began in 1907 (it took seven years to complete) it made an enormous impact on the quiet village of Crossens. Jobs, bustle, pride and different social attitudes suddenly arrived, but here the camera captures a moment that was typical of a decade before. The early morning scene sees a baker's horse-drawn van being led down the railway bridge on its way to deliveries in Crossens. The clock in the works tower shows five past eight, but the road and pavements are all but empty.

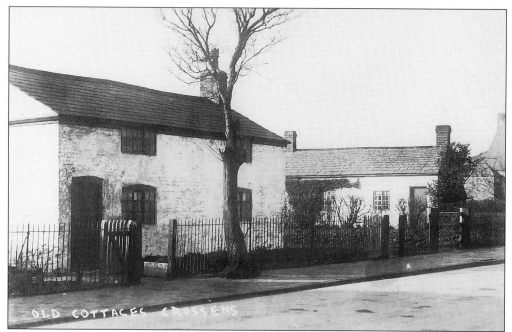

Old cottages, Rufford Road, 1910. These were situated opposite Brook Street. On the left is the home of Tom Hosker, formerly the village sub-postmaster, whilst to the right is William and Elizabeth Parker's cottage. Just visible at the extreme right is the Primitive Methodist Chapel.

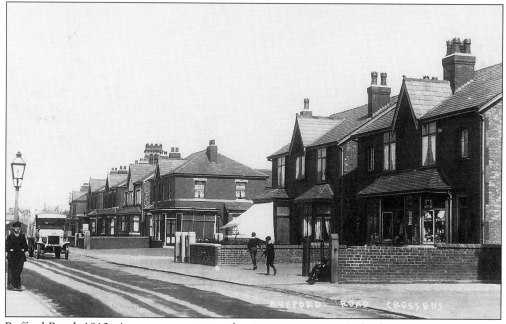

Rufford Road, 1912. A young man passes the time on a summer's day leaning on a lamp-post between Land Lane and Brook Street, while across the road the boys play. The message on the back of this postcard, sent by Ivy to her friend Edgar Brooke in Keighley on 30 July 1912, extols the thrills of the 'Joy Wheel' at Southport's fairground.

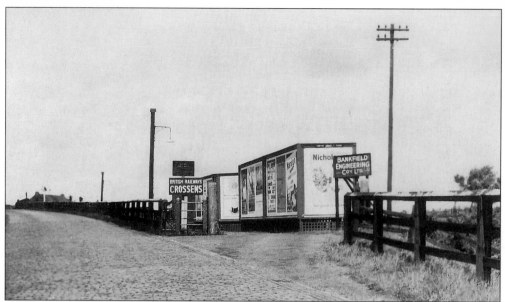

Bankfield Lane approach to Crossens station, 23 June 1950. This was also the access road to the Bankfield Engineering Company, coachbuilders and sheet metal workers, whose premises lay adjacent to the Preston to Southport platform. A bright, new board proclaims the nationalisation of the railways two years earlier in 1948. The station closed in 1964.

North Road telephone kiosk, 18 April 1935. Situated on the island at the junction with Rufford Road, this excellent example of a pre-war public telephone served the Crossens community well. It was particularly convenient for the many residents of the recently built houses in North Road and Ribble Avenue, who had taken advantage of the council's large home-building programme at the end of the Great War.

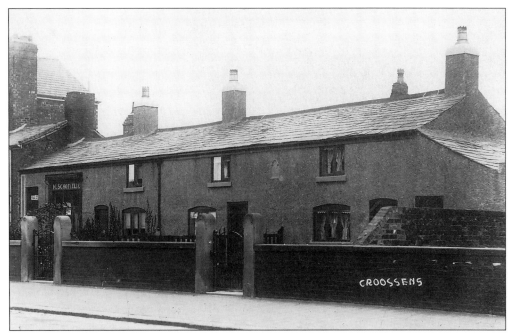

Old cottages, Rufford Road, 1912. This fine row, situated adjacent to the Co-operative Stores on the corner of Land Lane, dates back to the time of George IV in the 1820's. On the extreme left is the large Co-op building, and next door a notice at Mary Schofield's confectionery shop announces 'Teas provided any time'. Note the quaint mis-spelling of 'Crossens'.

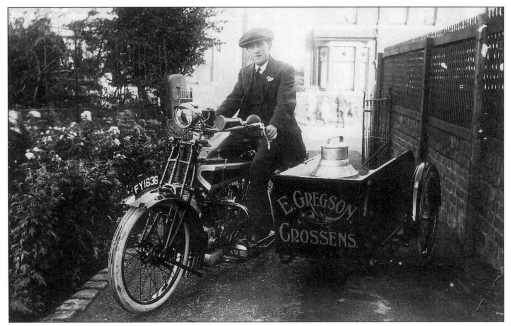

Edward Gregson, dairyman, Rufford Road, 1914. Mr. Gregson poses in Sunday best astride his new motor-cycle, complete with side-car which was used for the milk deliveries. The photograph was taken in the driveway of his dairy premises at 55a Rufford Road. The family business, started in 1911, served the Crossens community for over sixty-five years.

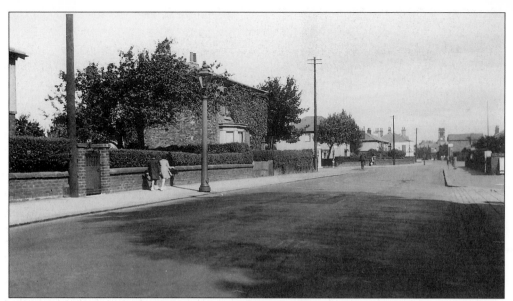

Rufford Road, 1937. Bathed in morning sunlight, Crossens' main thoroughfare on this mid-September Saturday is as peaceful as can be. A cyclist has the whole road to himself. Very few folk owned cars, and depended either on the train or, for the majority, a Corporation bus to get to town, but there isn't much of a queue at the bus-stop opposite North Road here. The two girls on their errands are about to pass the ivy-clad Liverpool House, a local landmark on the corner of North Road.

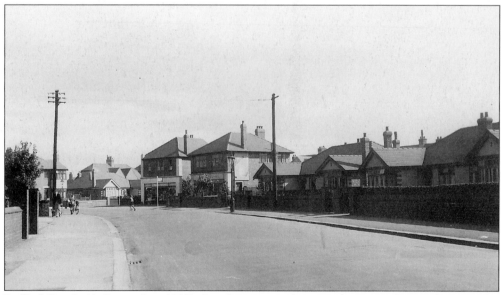

Rufford Road, 11 September 1937. Another view taken on the same day as the previous photograph. The Crescent is visible immediately to the left of Bamford's sweet shop, while Hennessey's grocery store next door displays a large advertisement for Palethorpes sausages on the side wall. Again, there is no motor traffic in evidence.

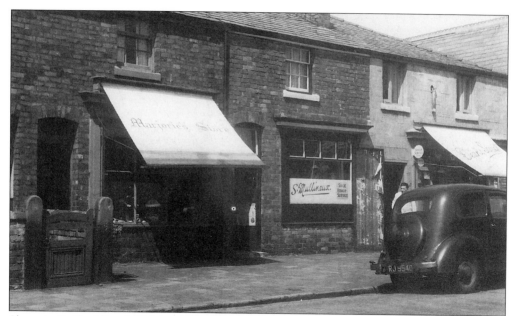

Shops in Rufford Road, 28 May 1957. This row of shops at 131, 133 and 135 Rufford Road was situated in the centre of the village next to the Methodist (formerly the United Methodist) church, the roof of which can just be seen at the top right of the picture. Left to right: Marjorie's Store was a drapers, S. Mullineux a boot and shoe repairer (the smell of leather inside was quite intoxicating!) and Norman Dean was a grocer.

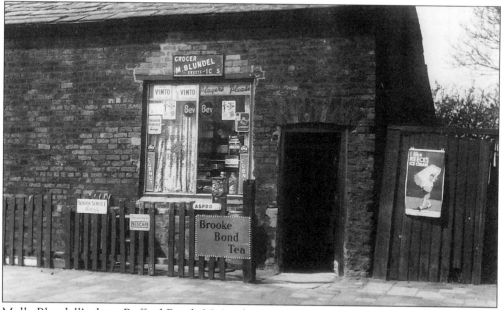

Molly Blundell's shop, Rufford Road, 26 April 1957. Situated opposite the vicarage, and close to the school, this is one of Crossens' oldest buildings. For many years it was the favourite haunt of the schoolchildren, who would spend their pocket money on the delights inside, Molly's penny lolly ices being a particular attraction. Later, when the shop closed and became Molly's lounge, the cottage looked very picturesque, becoming almost overgrown with Virginia creeper and sporting tall hollyhocks of every hue.

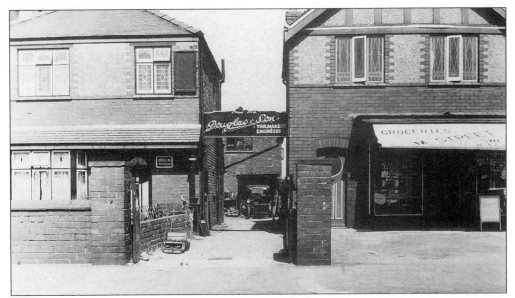

Houses in Rufford Road, 1950. Although not noted for its industry, Southport has seen trade and manufacture flourish over the years in the hundreds of former stables and outhouses tucked behind private residences. A typical example is the firm of E.J. Douglas and Son, toolmakers and engineers, seen here at 25a Rufford Road on a bright morning in June. On the left is the home of Harold Allan, painter and decorator, and on the right Street's grocery and sweet shop advertises Eldorado ice cream.

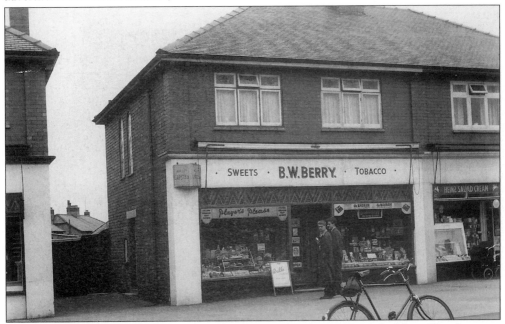

Shops in Rufford Road, June 1955. These were situated at the station end of the village between New Lane and The Crescent. Next to Berry's is John Woodruff's grocery shop (with the pram outside), whilst on the left, almost entirely out of view, is Roland Robinson's, confectioners. Robinson's also served as the local post office until a more central location was provided at the corner of Brade Street shortly after this photograph was taken.

Two

Churchtown and Marshside

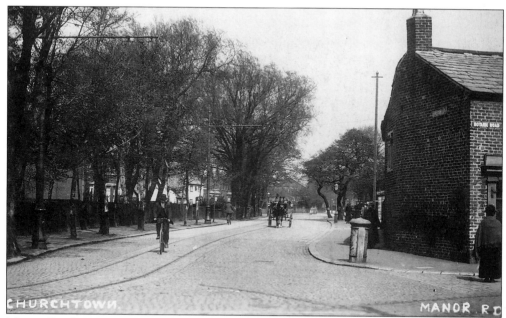

Manor Road, *c.* 1910. Viewed here from the Botanic Road junction, the tree-lined road stretches away from the heart of Churchtown towards Cambridge Road, Marshside Road and thence to the shore – a route dating back many centuries. The tram lines lead to the old Churchtown depot of the Southport Tramways Company (entrances in Cambridge Road and Manor Road) and did not serve passengers along this short length.

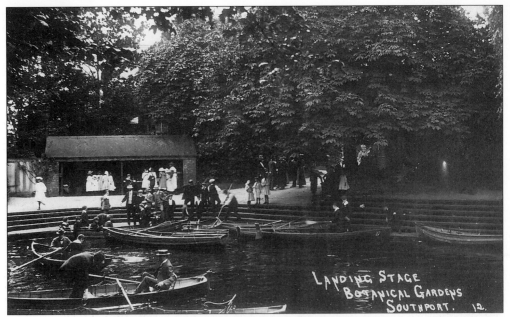

Landing stage, Botanic Gardens, 1914. Men and boys take to the water whilst the ladies keep to terra firma, during the final days of peace before the Great War. Just how many of these folk were enjoying an English summer for the very last time will never be known.

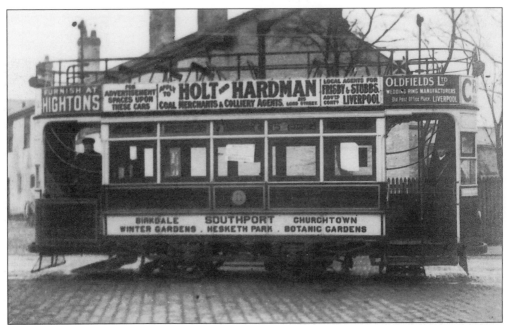

Corporation tramcar, Botanic Road, 1905. The open-topped car is seen outside the Hesketh Arms Hotel at the start of its journey to Birkdale. The electric tramway service was introduced in June 1900 when the Mayoress, Mrs Griffiths, started the first car, and finally came to a close on New Year's Eve, 1934. The gauge of track was 4 feet 8½ inches. During 1905 nearly four million passenger journeys were undertaken along the 13½ miles of street route.

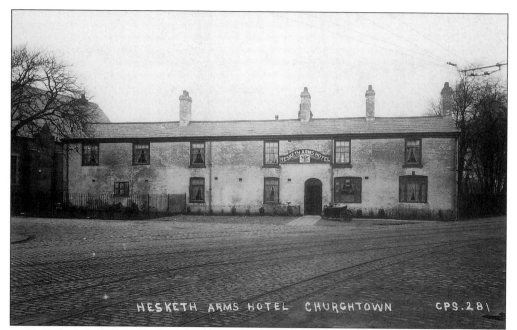

Hesketh Arms Hotel, Botanic Road, 1913. The Heskeths and the Bolds, lords of the manor, are commemorated in the two Churchtown inns bearing their names. In 1776 William Sutton, the so-called founder of the town of Southport, became landlord here when it was known as the Black Bull. Above the doorway is a board showing the arms of the Hesketh family, a twin-headed eagle.

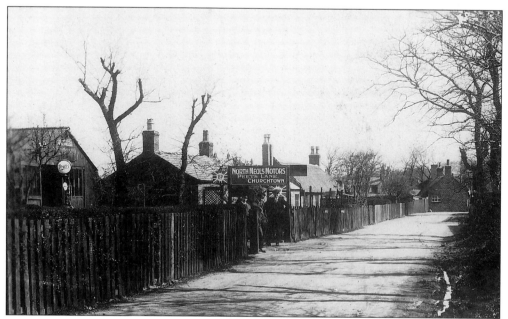

Peet's Lane, 1928. This view is looking towards Botanic Road from the corner of Bibby Road. On the left is the newly-established garage owned by John Goulder, North Meols Motors.

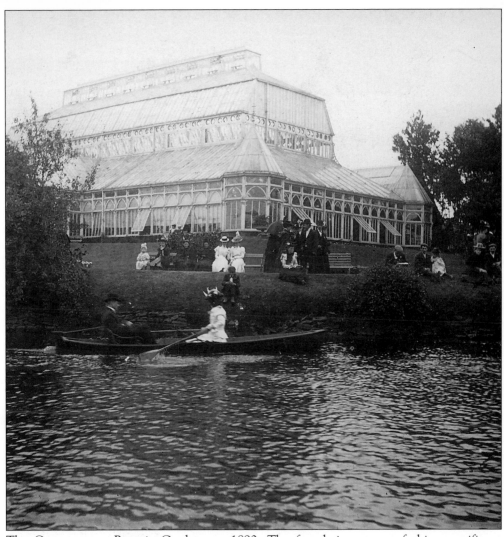

The Conservatory, Botanic Gardens, c. 1890. The foundation stone of this magnificent structure was laid by the Reverend Charles Hesketh, rector of North Meols, on the occasion of the opening of the gardens on 15 May 1875, the year before his death. Like so many of Southport's grand Victorian buildings, the Conservatory has been demolished.

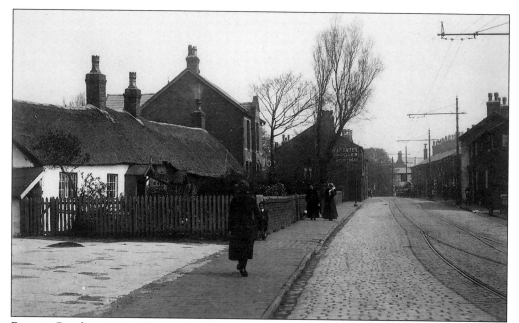

Botanic Road, *c.* 1920. This is the view from outside the Co-operative Society, near to the corner of Manor Road, looking towards the Hesketh Arms Hotel. The tall building next to the thatched cottages is Churchtown police station, and beyond that is W.J. Porter's saddlery. Note the tramlines converging to single track through the narrow part of the road.

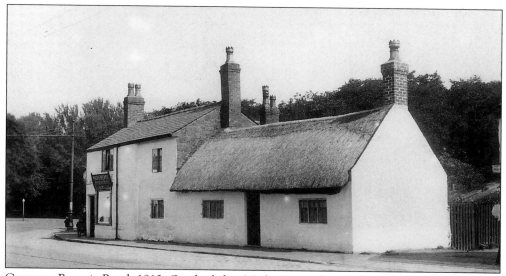

Cottages, Botanic Road, 1913. On the left is Madge Brewer's tea rooms. Her original premises were in Queen's Road, close to Hesketh Park, and these rooms were within yards of the very popular Botanic Gardens. To the right of the picture is the path leading to Hunt's Cottages, and behind are the wooded grounds of Meols Hall.

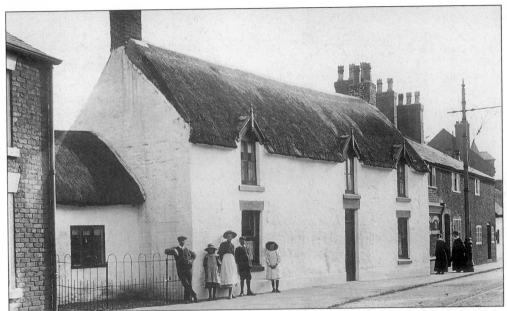

Old cottage, Botanic Road, *c.* 1910. A short distance away from Madge Brewer's (see previous photograph), in the direction of Mill Lane, is this splendid two-storey thatched cottage occupied by Richard Johnson and his family, seen here standing in the afternoon sunshine.

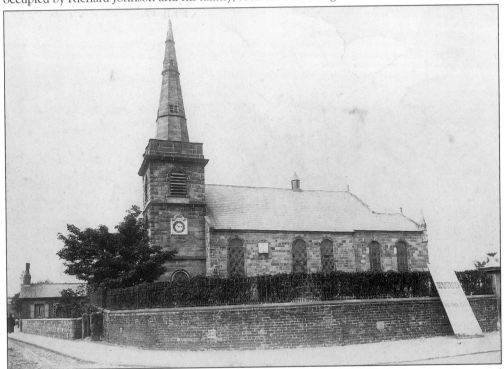

St. Cuthbert's church, *c.* 1890. This is how the church looked before the alterations and enlargement of 1908-9. The date of 1739 above the clock signifies the completion of the major rebuilding which had begun in 1730, and which saw almost all of the previous structure replaced. The site of the old village stocks is clearly seen in the wall recess to the left.

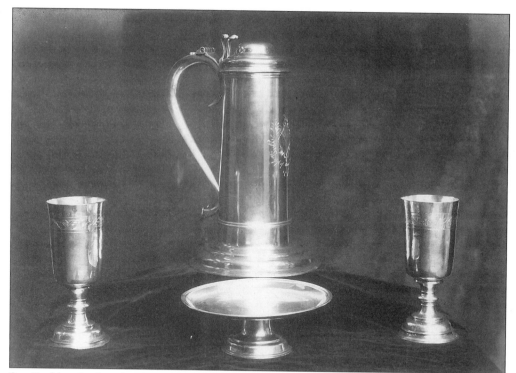

St. Cuthbert's church plate, photographed in 1905. The cups date from 1579 and 1607 (London), the paten from 1713 (Chester) and the flagon from 1756 (London). The last-mentioned is inscribed 'The Gift of Mary Hesketh 1757'.

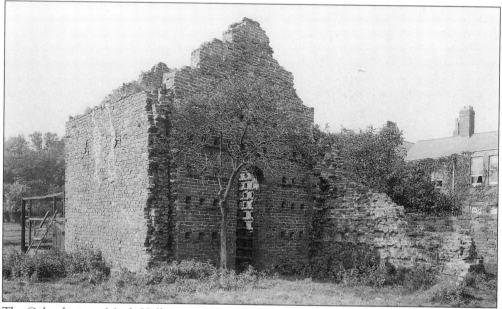

The Columbarium, Meols Hall, 1907. Dating back to the 1650's, the columbarium, or dovecot, was a ruin long before permission was granted to demolish it in 1991. Nevertheless, its repute as one of Southport's oldest surviving buildings made the application to demolish it a controversial one.

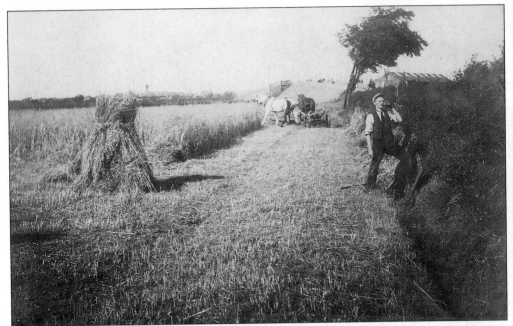

Harvest time, Bankfield Lane, 1906. Beyond the cornfield St. John's church, Crossens, is visible, while right of centre is the bridge over the Southport to Preston branch of the Lancashire and Yorkshire railway. The following February, work began on building the Vulcan Motor Works, and the view here, across the railway line and into Crossens, became impeded for ever. Today, housing in Merlewood Avenue and Bankfield Lane occupies this field.

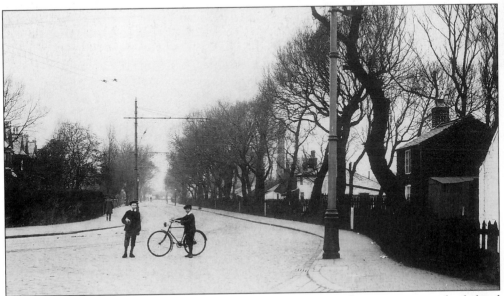

Mill Lane, 1913. The chimney of Churchtown corn mill can just be seen, centre right, behind the trees. In earlier times a windmill stood on the site, but the sails were removed five years after an auxiliary steam engine was installed in 1856. Several of the cottages on the right of the lane still survive. Only the next tram is likely to disturb the two boys.

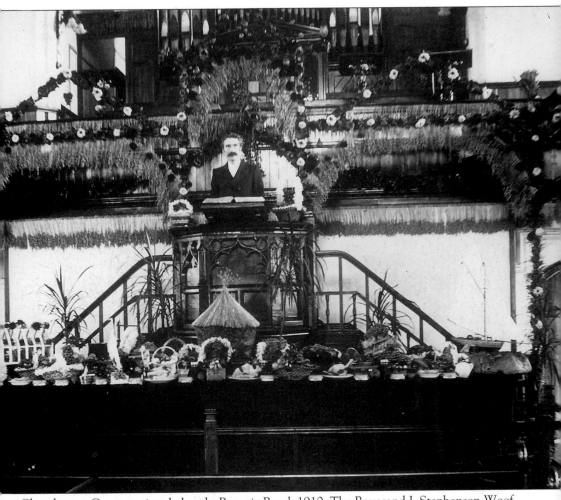

Churchtown Congregational church, Botanic Road, 1910. The Reverend J. Stephenson Woof, whose ministry spanned the years 1905 to 1913, is pictured in the pulpit on the occasion of the harvest festival. The most notable event during his period in office was the celebration of the church's centenary in 1907, when the *Southport Visiter* devoted two pages almost entirely to an account of the events and to the history of the church.

Thomas Blundell's house, 122 Cambridge Road, 1911. Daughter Doris stands in the early afternoon sunshine. During the 1920's the house was partially converted to a shop when Doris became the proprietor of a millinery business. The building later became the Churchtown branch of the Trustee Savings Bank, its appearance altering beyond recognition to that which is seen here.

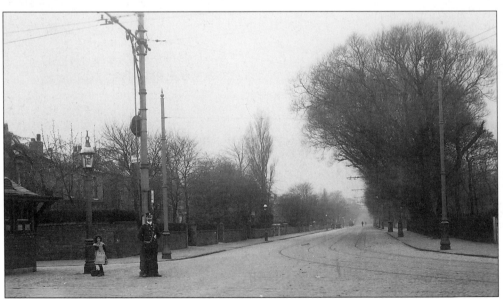

Roe Lane from Mill Lane, 1910. A smiling conductor stands by the tram station at Lane Ends, that is the junction of Roe Lane, Mill Lane, Moss Lane and High Park Place. The tram routes not only covered the lengths of Roe Lane and Mill Lane, but also took in High Park Place en route to Old Park Lane and Bispham Road. Lane Ends was for generations a popular meeting place for local folk.

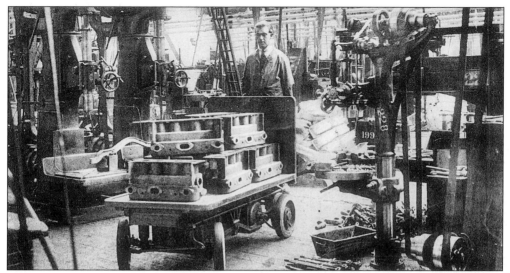

The British Electric Vehicles Works, Cambridge Road, 1924. When Southport Corporation abandoned the tramshed in Cambridge Road in the early 1920's, it was converted into a factory producing electric service trucks and small locomotives. These were sold to various industrial and railway companies, and even to the French naval yards. However, the company soon went into liquidation and was taken over by Messrs. Wingrove and Rogers Ltd. of Old Swan, Liverpool, on 30 September 1926, when work at Churchtown ceased.

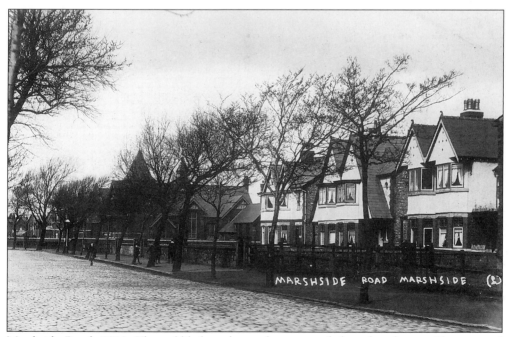

Marshside Road, 1913. The cobbled roadway often resounded to the clatter of hooves and cartwheels, as shrimpers made their way to and from the shore. Behind the trees, at the corner of a primitive Larkfield Lane, is Emmanuel school, which at the time had a roll containing the names of 148 children.

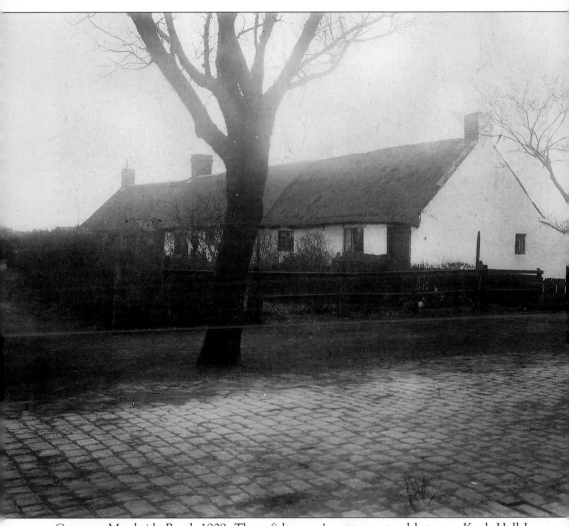

Cottages, Marshside Road, 1909. These fishermen's cottages stood between Knob Hall Lane and Fleetwood Road. They survive today, somewhat altered, but recognisable nevertheless.

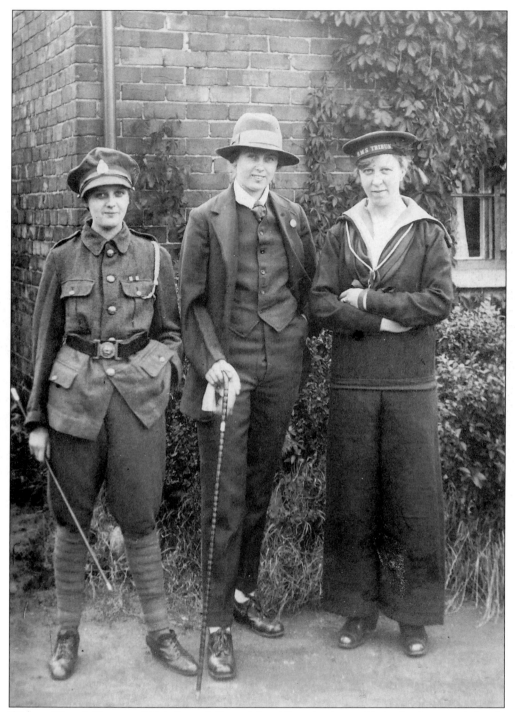

Girls at Cotty's Brow, c. 1914. From left to right: Alice Aughton, Doris Aughton and Annie Wright, all from Cotty's Brow, dress up in the manner of Vesta Tilley, the celebrated variety artiste and male impersonator. This lovely moment was captured for all time by the little-known Southport photographic company, Courtney and Farnell. Cotty's Brow was – indeed still is – just off Knob Hall Lane.

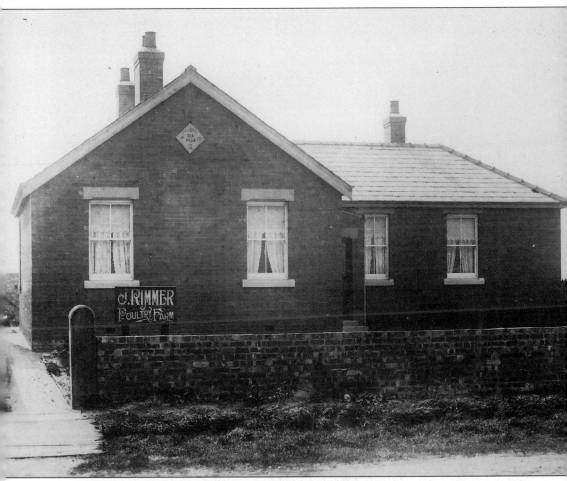

Sea Villa, Marshside Road, 1918. The grandly named bungalow was occupied by poultry farmer John Rimmer, and was the most northerly dwelling in Marshside Road, close to the sea embankment. Built in 1910, it still survives.

Three
Miscellaneous Suburbia

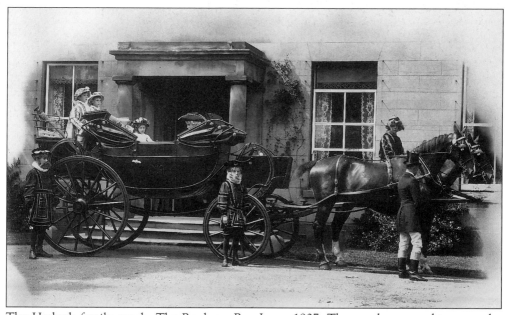

The Hesketh family coach, The Rookery, Roe Lane, 1907. The coach was used to carry the Rose Queen, Lucy Fleetwood Hesketh, to the grounds of Meols Hall on the occasion of her crowning on 29 June. The coachman is Thomas Arnold. At the time the photograph was taken, the coach had been in the family for about 100 years. In its glory days it used to take the family to Dorset, from whence it would be shipped across to France; it would then resume its duties and convey its owners to Italy.

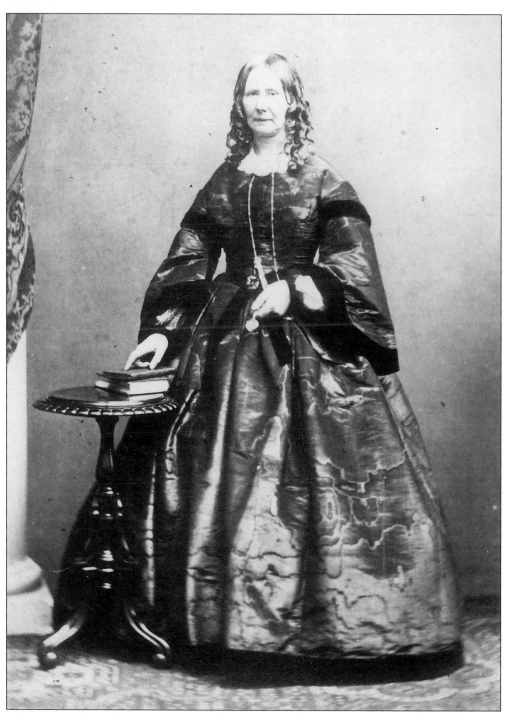

Anna Maria Alice Hesketh, lady of the manor. Wife of the Reverend Charles Hesketh, rector of North Meols until his death in 1876, the benevolent Mrs. Hesketh was the great-grandmother of Roger Fleetwood Hesketh, who became Mayor and Member of Parliament for Southport. She died in 1898, aged 89. The photographer is Henry Sampson, the most prominent of Southport's mid-Victorian camera artists.

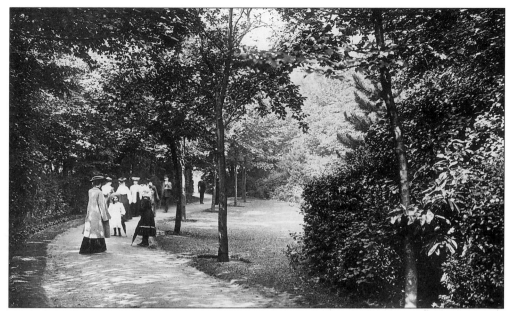

Hesketh Park, 1906. A bright summer's day, with sunlight streaming through the trees, and strollers in their Sunday best, gives a feeling of timelessness to this peaceful Edwardian scene, yet less than forty years earlier the park did not exist, the area being simply barren sandhills. The transformation began when the land, about thirty acres in all, was donated to the town by the Reverend Charles Hesketh for the purpose of creating a public park. It opened on 1 May 1868.

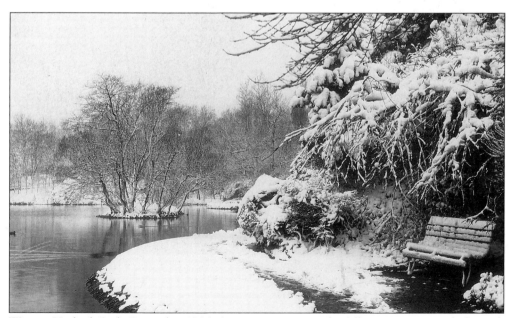

Winter, Hesketh Park, December 1906. A contrasting scene the following winter, with the park transformed into a winter wonderland.

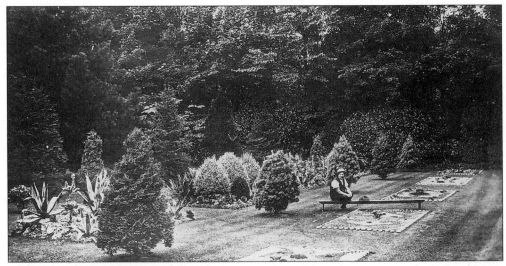

Gardener, Hesketh Park, *c*. 1909. For many years the park was a jewel in Southport's attractions, perhaps never more so than in Edwardian times. When this photograph was taken, the grounds offered a wide variety of gardens and flower beds, a large conservatory, a well-stocked aviary, an ornamental lake, astronomical and meteorological observatories, rockeries and winding paths. Here a gardener takes a short rest from his work maintaining the beautiful carpet gardens.

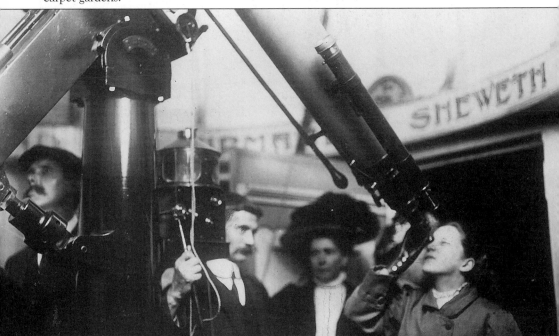

Astronomical Observatory, Hesketh Park, *c*. 1901. In 1871, just two years before his death, John Fernley provided the meteorological and astronomical observatories situated in the newly created Hesketh Park. The telescope's original mounting column still survives, as does the biblical text which has surrounded the apparatus for well over 100 years. It is taken from Psalm 19, and reads 'The Heavens Declare The Glory Of God; And The Firmament Sheweth His Handywork [sic]'.

Park Crescent, 1879. An interesting view of the early housing opposite Hesketh Park, the park lodge (which still survives, thankfully), and a glimpse of the unpaved wasteland on the corner of Queen's Road and Park Road. The picture was taken by Benjamin Wyles, one of thirty-seven prominent photographers who worked in Southport between 1850 and 1900.

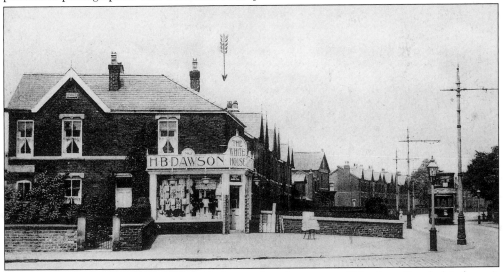

The White House, Old Park Lane, 1910. Situated on the corner of Heysham Road, this draper's shop was run by Herbert Dawson. A contemporary advertisement indicates that Mr. Dawson was the sole agent in Southport for 'Blakey's Famous Plaster'. The business closed shortly after the photograph was taken.

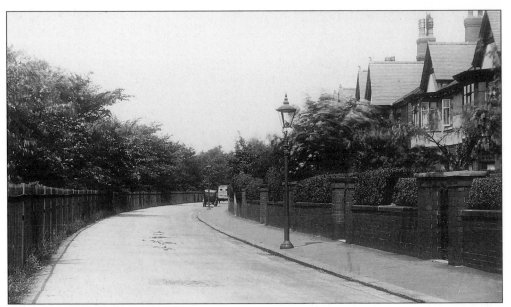

Norwood Crescent, *c.* 1935. Tucked away behind the thoroughfare of Norwood Avenue, this quiet road was seldom seen by either motorist or casual pedestrian. To the left, screened by trees, is the L.M.S. railway line between Hesketh Park and Meols Cop stations. The character of the place is rather different today, with schools occupying the site of the long-since closed railway.

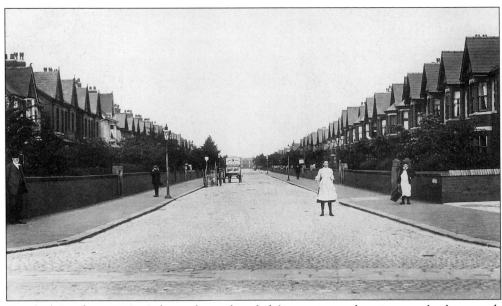

Hereford Road, *c.* 1912. A horse-drawn bread delivery van makes its way slowly towards Heysham Road, while staff from William Smith's bakery, just out of view on the corner at 47 Norwood Avenue, pause for the cameraman. In the distance, houses in Old Park Lane are just visible.

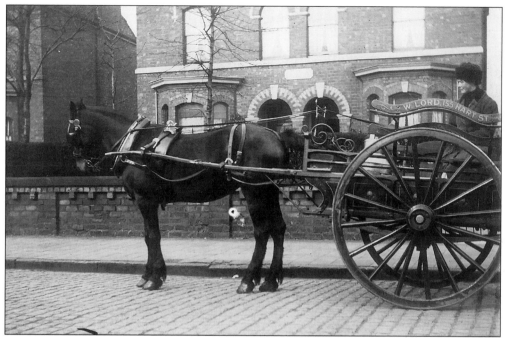

Woodhead Lord's milk delivery cart, 1910. Mr. Lord, of 155 Hart Street, was a well known and long-established dairyman, who served the Blowick district before the Great War and throughout the inter-war years. He was a man of some taste, if the appearance of his early transport, with its fine curving lines, is anything to go by.

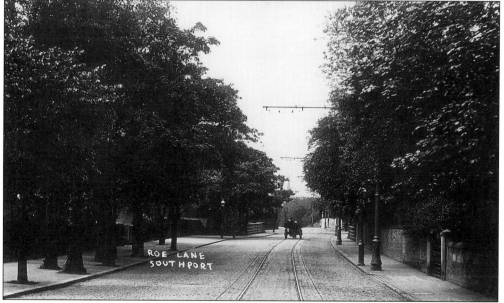

Roe Lane, c. 1906. The view looks towards the bridge over the Southport to Preston railway line, from the Churchtown side. The junction with Norwood Avenue can just be seen beyond the wooden fence on the left. The driver of the horse and cart seems quite oblivious to the possibility of an oncoming tramcar from over the bridge. Pavements and gardens were certainly well wooded in this part of the town!

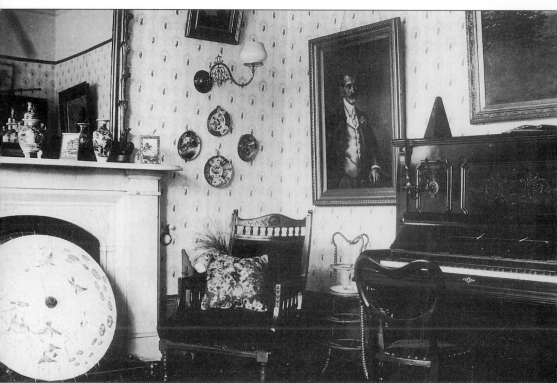

Drawing-room, Craven Lodge, 45 Leyland Road, 1908. The home of Mrs. Franklyn Ashley was typical of the numerous well-appointed Victorian and Edwardian residences located in Southport. Expensive furniture and paintings fill the room. The decorative parasol placed in the hearth spent many a summer day protecting Mrs. Ashley from the sun, as family photographs reveal.

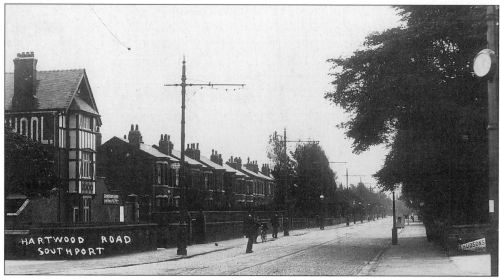

Hartwood Road, 1911. Looking from the junction with Manchester Road and Roe Lane, towards St. Luke's Road, the view includes Gandy's riding school and livery stables on the left, proprietor George Bennion.

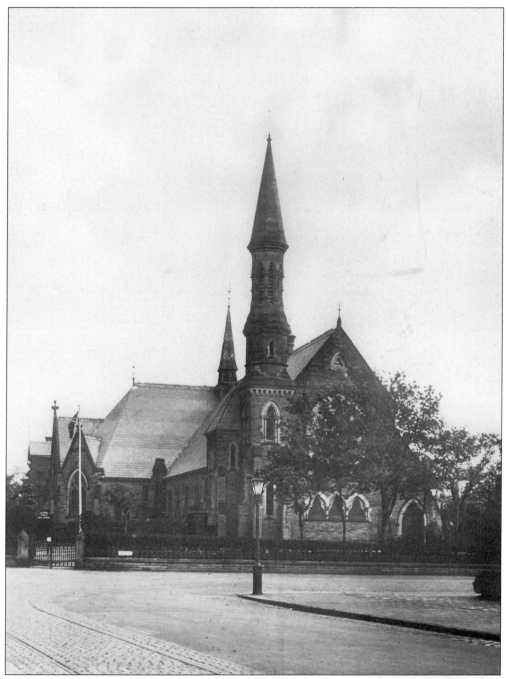

All Saints church, Queen's Road, *c.* 1912. To many lovers of Southport's church architecture, All Saints was (for it is no more, having been destroyed by fire in 1977) the most beautiful of all. The pleasing features included the minaret-style tower, the superb rose window in the western gable, and the contrasting shades of the blue roof slates. Its foundation stone was laid in 1870 by Anna Maria Alice Hesketh, wife of the Reverend Charles Hesketh, rector of North Meols, and for a time Mrs. Hesketh was the church organist. It was originally built as a chapel-of-ease to St. Cuthbert's in Churchtown.

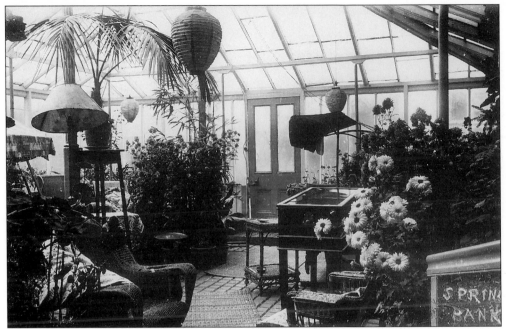

Spring Bank Private Hotel, 6 Church Street, 1933. A preponderance of wickerwork in a congested conservatory gives a somewhat Edwardian feel to the surroundings in Mrs. Helen Birks' establishment, but the photograph dates from much later.

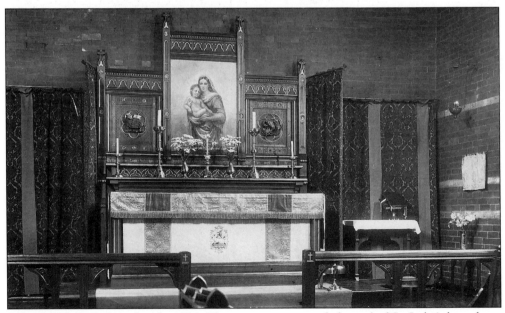

Side chapel, St. Luke's church, 1934. The exterior, nave and chancel of St. Luke's have been photographed frequently over the years, but this simple, yet beautiful, side chapel much less so. The church's foundation stone was laid in October 1878 by Lord Skelmersdale, and the church consecrated by the Bishop of Liverpool on 17 October 1882. It opened as a chapel-of-ease to Holy Trinity.

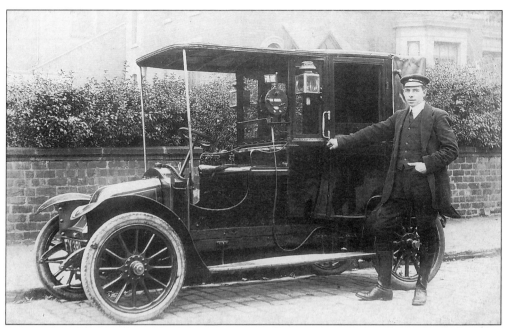

George Gwynne, taxi driver, 1914. Mr. Gwynne, of 103 Kensington Road, stands alongside his pride and joy – one of Southport's early motor taxis. The vehicle registration number indicates that it had already been on the road for seven years prior to this photograph being taken.

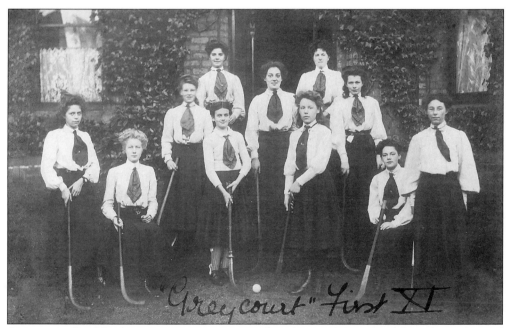

"Greycourt" First XI

Greycourt school hockey team, 1907. Greycourt boarding and day school for girls was located on the south side of Queen's Road at the corner of Leyland Road, town side. Run by Miss Annette Adams, it was she who sent this postcard of the hockey First Eleven to a relative in Sheffield. The large and fine houses in Southport readily lent themselves to the development of private schools, and more than forty such existed in the early part of the century.

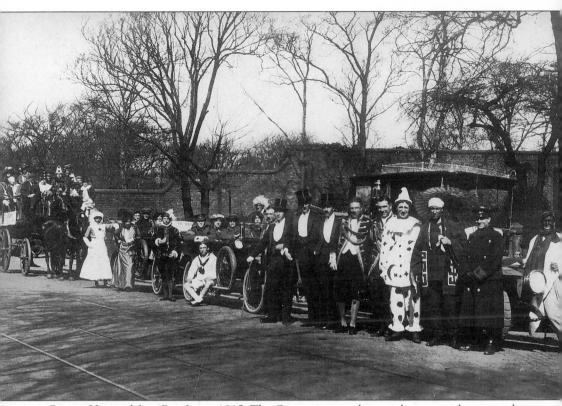

Grange Hospital fête, Roe Lane, 1915. The Grange was a substantial nineteenth-century house situated on the corner of Roe Lane and Grange Road, on the site now occupied by Grange Avenue. For many years it had been the home of Colonel Welsby and his family, but just before August 1914 it fell vacant. It was used as an auxiliary hospital for convalescing soldiers during the Great War, and temporary buildings were erected in the extensive grounds to be used as wards. Occasional fêtes were organised to keep up spirits and raise money, and this is one such event, with the fancy dress participants assembling in Roe Lane prior to a procession.

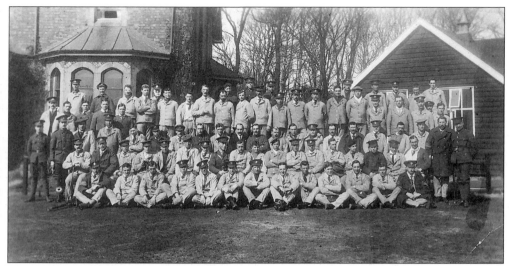

Grange Hospital patients, *c.* 1915. Apart from the occasional eye-patch, crutch, walking-stick and arm sling, this group of wounded soldiers appears to be in reasonable shape. Far better to be here in Southport than in France.

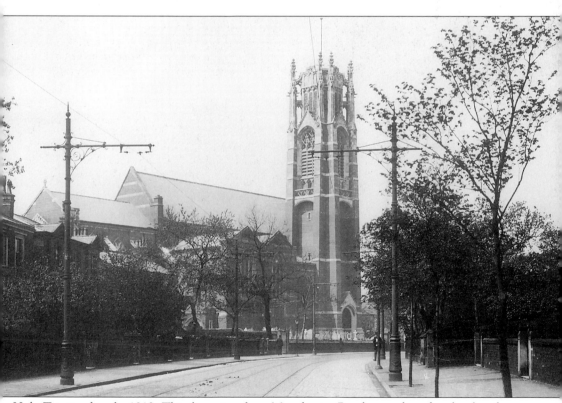

Holy Trinity church, 1913. This fine view from Manchester Road was taken shortly after the rebuilding. The clock has not yet been installed in the tower. The original church on this site was consecrated in 1837, but the new structure was without doubt much more impressive both in beauty and proportion. Note the magnificent foliated pinnacles at the corners of the tower.

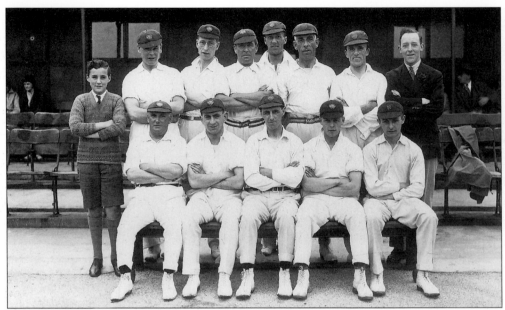

West End Cricket Club at The Rookery, 4 August 1930. The team, members of the Southport and District Amateur Cricket League, is pictured before the match against YMCA which brought victory to win the Sandhurst Shield. Back row, left to right: Sydney Thompson (scorer), J. Barton, H. Fielding, E. Barton, E. Haberland, H. Ball, A. Hilton, J. Gledhill (reserve). Front row: Tommy Thompson, I. Shaffer, A. Wilkinson, R. Miley, W. Rimmer. West End had never won the trophy before.

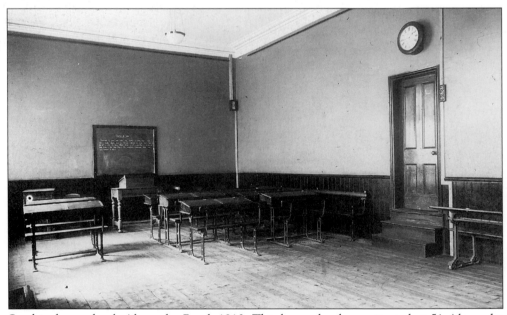

Sandringham school, Alexandra Road, 1910. This boys school was situated at 51 Alexandra Road, the principal being Mr. Richard Chadwick. The austere room seen here was known as 'the big classroom'. It was used for assembly, prayers and private study.

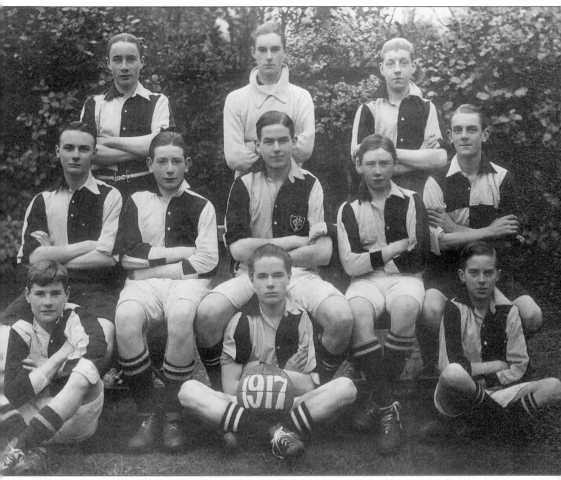

Sandringham school football team, 1917. Back row, left to right: R.A. Pennington, S.H. Williams, J.E. Tong. Middle row: A.A. Edwards. R.H.L. Foster, C.H. Newton (captain), S.E. Davies, O. Potter. Front row: D.C. Darrah, E.T. Darrah, J. Fawcett. Potter is the odd one out, wearing a quartered shirt, whilst the others are dressed in halved ones. Only the captain merits a shirt badge.

Manchester Road, Leyland Road, Roe Lane and Hartwood Road, *c.* 1949. During the Second World War, the black-out caused a very high number of traffic accidents, despite the reduction of vehicles on the road. The restoration of driving test requirements and the relaxation of wartime lighting restrictions ensured that post war casualties were significantly fewer, but even so this scene, with a car lying on its side to the left of the picture in Leyland Road, and another disabled in the middle of the uncontrolled junction, was not particularly unusual, as a fresh generation of drivers attempted to come to terms with the demands of what, by today's standards, was rather unsophisticated motoring.

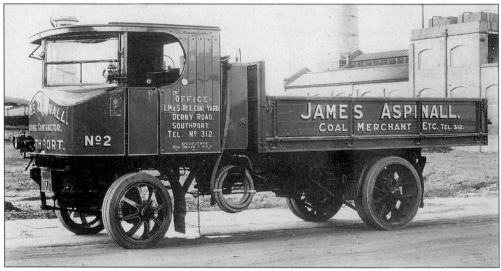

James Aspinall's steam wagon, 1926. Steam transport was seen only occasionally on the roads of Southport, but James Aspinall, coal merchant, invested in this marvellous tipping wagon which operated out of the L.M.S. coal yard in Derby Road. It had solid rubber tyres and a speed limit of twelve miles per hour applied. The photograph was taken as the vehicle was leaving the Sentinel Wagon Works in Shrewsbury.

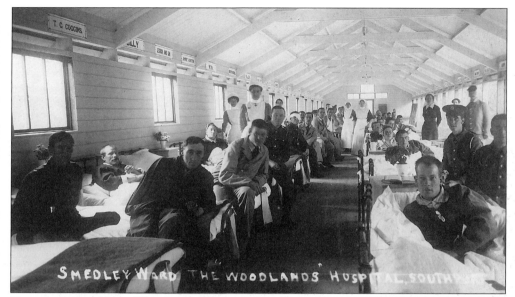

Convalescing soldiers, Woodlands Hospital, Manchester Road, 1917. Facilities were badly needed to cater for the many wounded soldiers who were repatriated during the Great War, so the mansion on the corner of Albert Road known as 'The Woodlands', which was standing empty, was converted into an auxiliary hospital. The temporary, purpose built Smedley ward was typical of other convalescent hospitals in the town at the time insofar as every available bed was occupied.

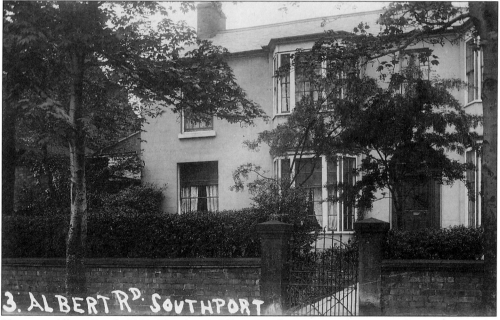

House in Albert Road, 1909. Number 3 Albert Road was situated opposite the grounds of the Woodlands (where the present fire and police stations stand). At the time of this photograph it was being advertised for sale. As well as its advantageous location so close to Lord Street, it featured five bedrooms and two sitting rooms, and was altogether a splendid and very comfortable house. In stark contrast, a petrol station now occupies the site.

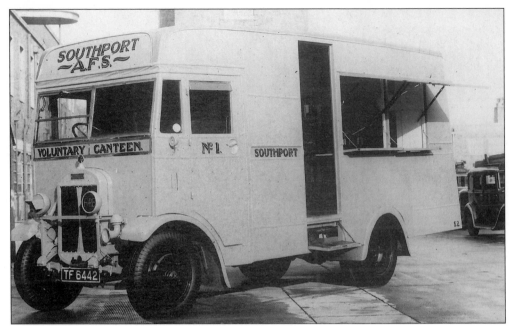

Auxiliary Fire Service canteen, Southport fire station, *c.* 1941. The Second World War saw Southport prepare its response to the perceived dangers of bombs and fires. An auxiliary fire service was introduced, and here an immaculately turned-out A.F.S. mobile canteen is seen at the newly opened fire station in Manchester Road. In the event, the town did not escape entirely from the ravages intended for nearby Liverpool.

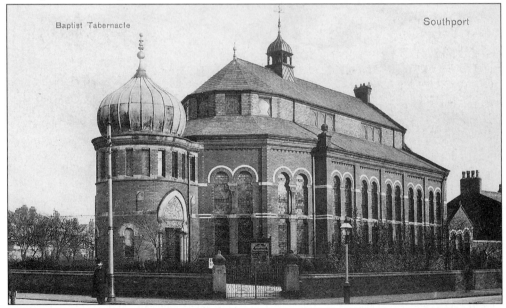

The Baptist Tabernacle, Scarisbrick New Road, 1906. This is a good example of the diverse architecture which the town has enjoyed as a result of Victorian imagination. The church was built in 1892 to cater for the growing Baptist congregation in Southport, supporting their original church in Hoghton Street. The building, sadly, has gone, but a new Baptist church now occupies the site.

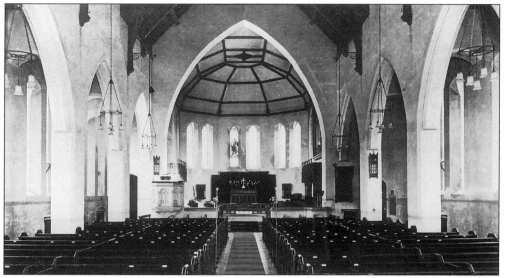

All Souls church, 1933. The first church of All Souls was built in 1898 as a chapel-of-ease to All Saints, Hesketh Park. It was an iron building, of temporary nature, and in 1912 foundations were laid for a permanent replacement. However, the Great War delayed progress, and by the time peace returned the cost of the original plans was prohibitive. A new design was therefore commissioned from local architect Henry Jones, and the foundation stone of the building pictured was laid in October 1921. It was consecrated by the Bishop of Liverpool on 23 September 1923. The church, on the corner of Norwood Road and Peel Street, has now been demolished.

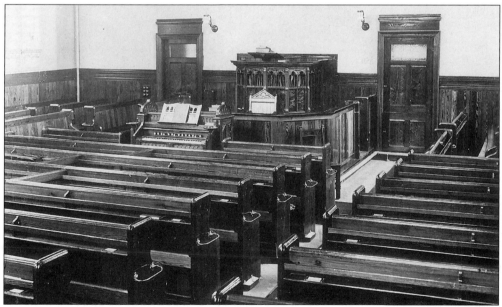

Welsh Chapel, Portland Street, 1910. Originally built in 1871 between Riding Street and the railway line to Liverpool, at a time when Southport was rapidly expanding, this Presbyterian chapel was typical of the diversity of Free Churches springing up all over the town in those years of change and expectancy. The interior is seen here on completion of the rebuilding in 1910.

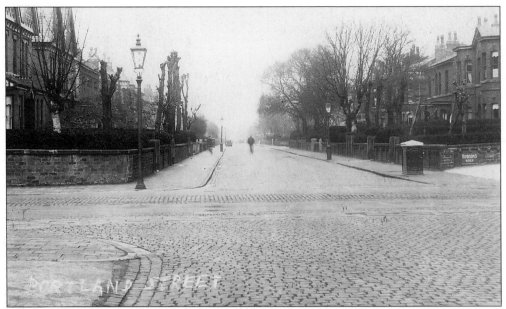

Portland Street, 1908. This is the view looking across Cemetery Road, in the direction of the town centre.

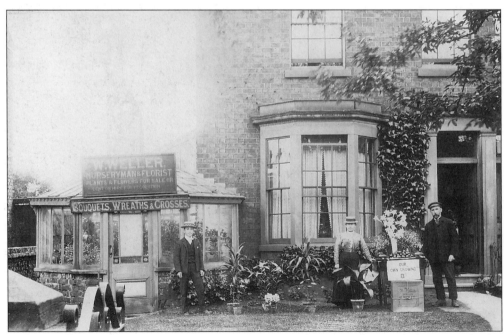

Walter Weller's nursery, Belmont Street, 1909. Mr. and Mrs. Weller, and their son, display some of the plants, flowers and vegetables on sale at their premises at 42 Belmont Street. Included in the services they provided was the hiring out of displays for decoration.

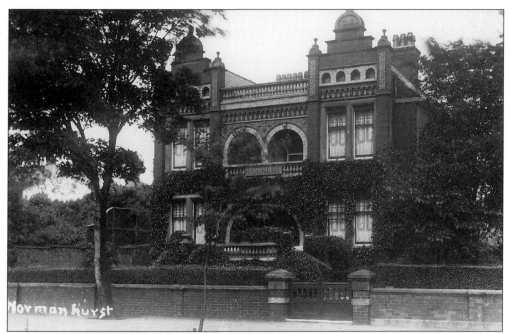

Normanhurst, Lord Street West, c. 1926. This interesting, indeed eye-catching, architecture is unique, so given the propensity over many years for destroying Southport's Victorian heritage, it is a blessing that the building still survives. It is situated close to Westcliffe Road, and served as a private hotel when this photograph was taken.

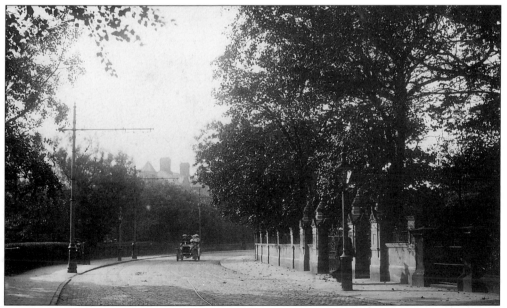

Lord Street West, 1906. The open road beckons for this motorist and his passengers as they make their way into Lord Street from Birkdale in late summer. Belle Vue, the residence of Sir George Pilkington, is behind the trees on the right. A tender message on the back of this postcard from Kitty to her 'dearest Tom' away in Workington concludes, 'I wonder how many times we have walked down here together. Oh, for some MORE times!'

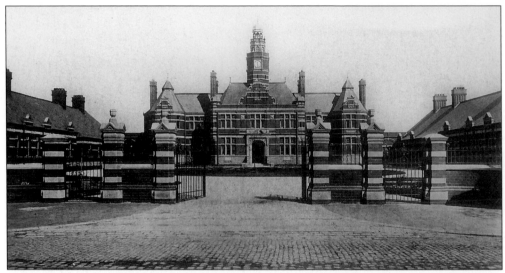

The Infirmary, Scarisbrick New Road, 1905. Built on land between Pilkington Road and Curzon Road, the New Infirmary, as it was known, was opened on 26 September 1895 as a replacement for the increasingly inadequate one situated in Virginia Street, which had been in use since 1871. The opening was the occasion for great celebration, typical of Victorian civic pride whereby important developments in the town were marked by the granting of holidays, processions and general revelry.

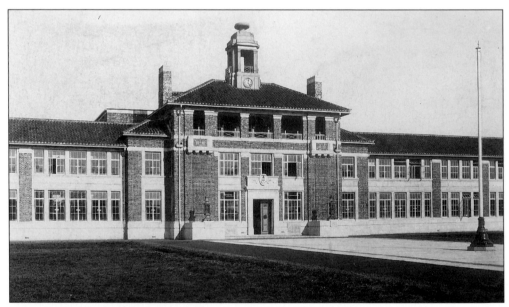

King George V school, Scarisbrick New Road, 1947. Opened in October 1926 by the Earl of Derby, KGV (as it was universally known) superseded the boys school at The Woodlands in Manchester Road. Unfortunately, the building's foundations were to prove unequal to the demands of the subsoil, and it soon became clear that it would only be a matter of time before the struggle to survive was lost. The building was eventually demolished in December 1982.

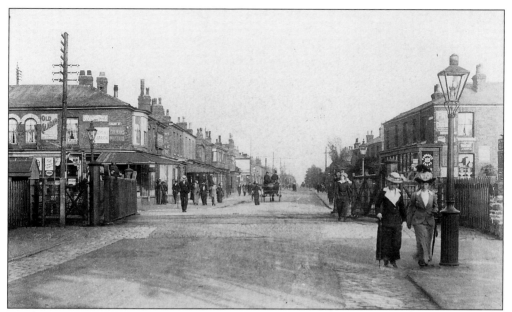

Level crossing, Duke Street, 1914. The street is still free of motor traffic in this view looking towards Shakespeare Street. Enamel advertising signs are seen in abundance on the upper walls – Old Calabar dog and poultry foods, Rowntree's cocoa, Colman's starch, Colman's mustard, Fry's chocolate, Hudson's soap – all common and typical of the period.

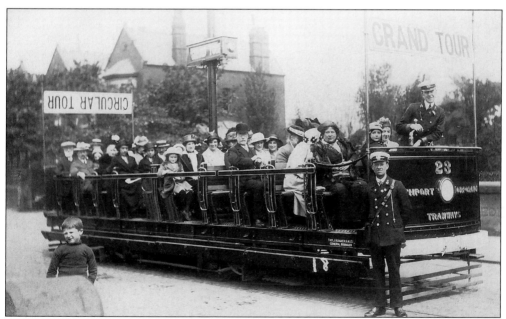

Touring tram, Duke Street, May 1915. This 'toast-rack' design was much favoured by visitors wishing to ride alfresco to see some of the sights. The driver and conductor of Number 23 pause outside the George hotel at a time when trenches were being dug and fought over in Europe. The absence of young men aboard, despite the presence of several young ladies, is no doubt partly explained by events taking place elsewhere.

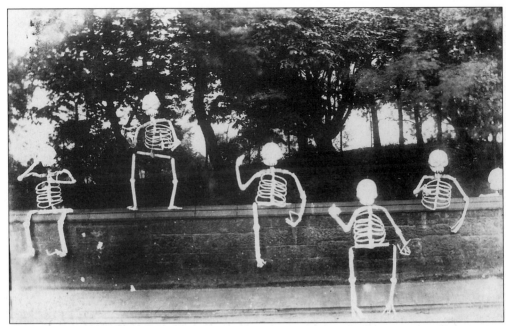

This photograph is one of a series of eight (four of which are reproduced here) intended to portray, in a humorous way, the attractions of the George Hotel in the early 1900's. The skeletons are cleverly superimposed, and the tale begins with their sneaking out of the cemetery, which lies adjacent to the hotel.

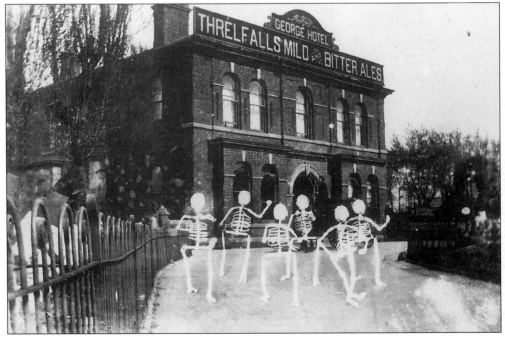

They make their way to the George, hardly able to contain their excitement.

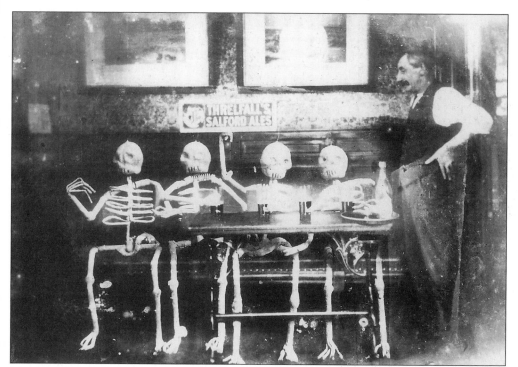

Mine host attends to their requirements, without a hint that there might be anything unusual happening...

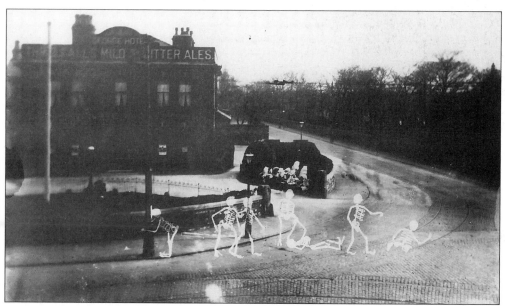

...and after an agreeable sojourn, the inebriated pals make their way, as best they can, back to the cemetery.

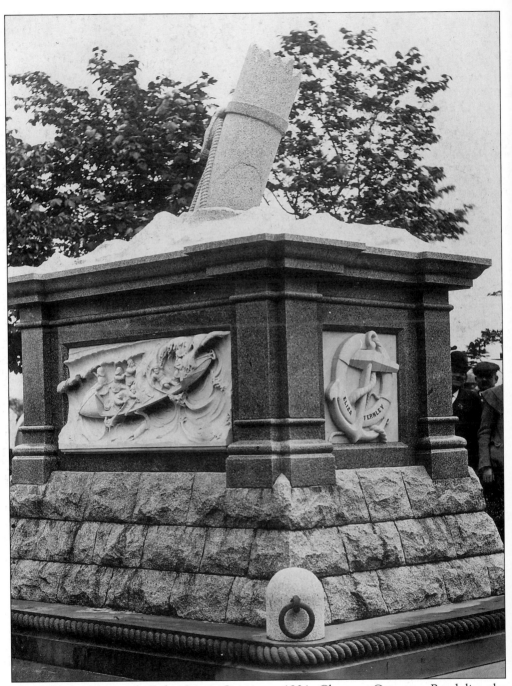

The Lifeboat Memorial, Duke Street Cemetery, 1904. Close to Cemetery Road lies the memorial to the fourteen Southport lifeboatmen of the *Eliza Fernley*, who lost their lives on the night of 9 December 1886 attempting to rescue the crew of the 400 ton barque *Mexico* of Hamburg, bound from Liverpool to South America. A further thirteen men from the St. Anne's lifeboat also died in the disaster, but the *Mexico* crew was saved by a third lifeboat, from Lytham. The panels give the facts and attempt to portray some of the horror, the monument being surmounted by a symbolic broken mast engulfed by the waves.

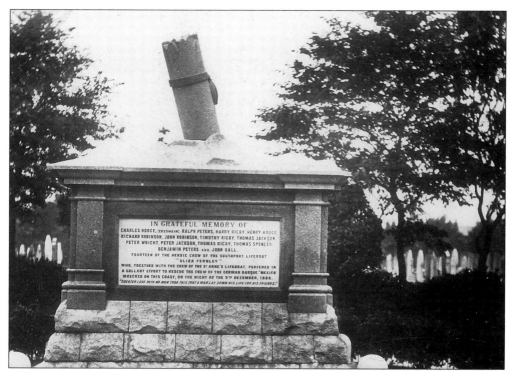

The Lifeboat Memorial, Duke Street Cemetery, 1904. The names of those who perished are inscribed on the panel.

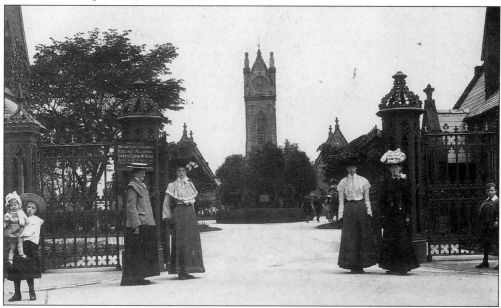

The Cemetery, Duke Street, c. 1908. The town's churchyards became increasingly incapable of providing adequate burial space during the rapid growth of the mid-nineteenth century. Consequently a large cemetery was laid out on the south-east side of Snuttering Lane (which became Cemetery Road). It opened in 1865. These are the ornate iron gate posts of the main entrance in Duke Street, in front of which is an interesting selection of period head-gear.

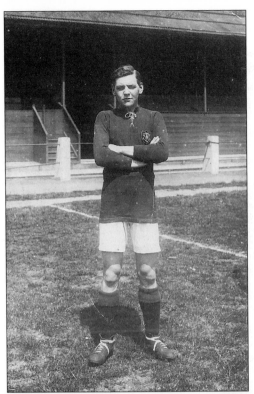

Jackie Sinclair, Southport Football Club, 1923. The Sinclair family is well-known in local football circles, having produced several players who have represented the town's team. Jackie was a promising youngster whose father, Jack, had played for Southport between 1896 and 1910. Jackie was not so fortunate, however. He died of pneumonia on 1 November 1924 aged only nineteen, a tragic and premature death, and a sad loss to the Club. He is pictured here in front of the grandstand at Haig Avenue.

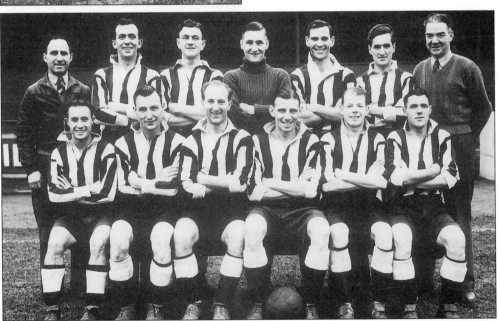

Southport Football Club, Haig Avenue, 1948-49 season. Back row, left to right: George Mutch (trainer/coach), Harry Harrison, Colin Beardshaw, Wilf Birkett, Ronnie Hodgson, Bob Hacking, R. Jones (assistant trainer). Front row: Harold Iddon, Les Owens, Cec Wyles, Ted Blagg, Kenny Banks, Jackie Marriott. It was a disappointing season for the club, the team finishing next to bottom of Division Three (North).

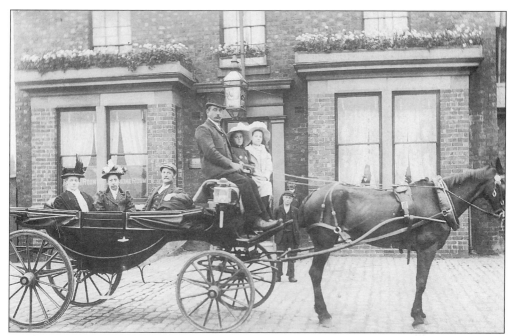

Landau, Blowick hotel, *c.* 1909. Situated in Norwood Road on the corner of Butts Lane, and next to Blowick railway station, the hotel was conveniently situated for visitors to the town from the Wigan and Manchester direction. Just behind the driver, a brass plaque on the wall indicates that the landlady, Mrs. Esther Brown, is an agent for the Britannic Assurance Company.

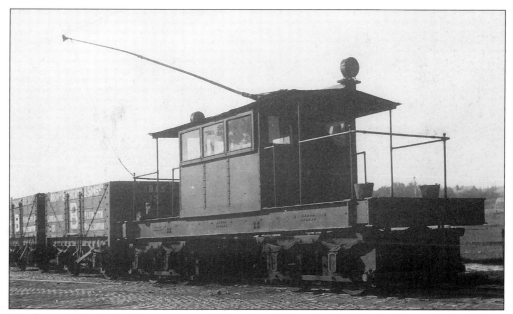

Southport Electricity Department locomotive, Blowick, 1935. A Corporation electric locomotive is pictured moving fuel trucks at the Crowlands Electricity Works.

Junction of Meols Cop Road and the borough boundary, Kew, 1945. Many road scenes in Southport look substantially different to what they did a few decades ago, but not many have altered as much as the site of the present Kew roundabout. The railway bridge used to carry the line to Altcar and Hillhouse.

This is the same location as in the previous photograph, but looking from Scarisbrick New Road.

Four
Town Centre

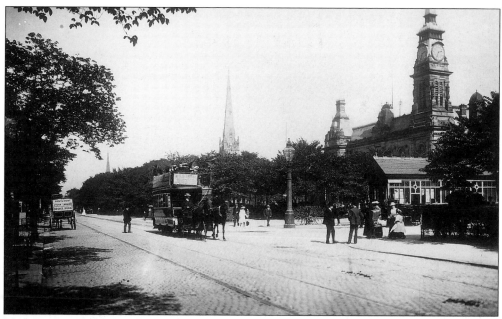

Lord Street and the Cambridge Hall, 1899. A well-laden tram pulled by a pair of horses makes its way at a leisurely pace towards Birkdale, whilst the popular Southport Steam Laundry of Sussex Road (which employed ninety-five staff at the time) does business at the Scarisbrick hotel. Horse-drawn trams, introduced in 1873, were displaced when the electric tramway service started in June 1900, so this view is one of the last ever taken of Lord Street before it was transformed by the introduction of electrification and the internal combustion engine.

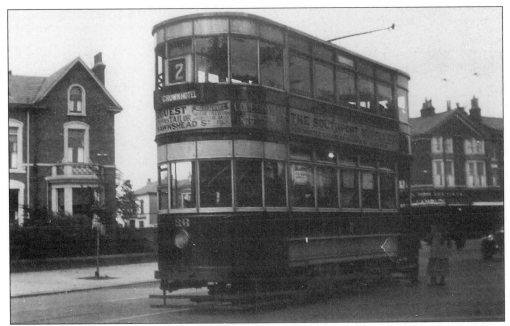

Tram entering Lord Street West, *c.* 1924. The Number 2 route from Lord Street to the Crown Hotel in Liverpool Road passed along Lord Street West, Aughton Road, Upper Aughton Road, Everton Road and St. Peter's Road.

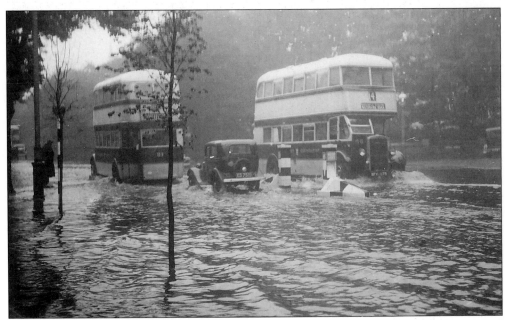

Flooding in Lord Street, 22 June 1936. For decades, until the introduction of improved drainage, Lord Street was susceptible to storm flooding. Road users became quite used to having to negotiate the waters. In this flood, the Number 14 bus is passing Portland Street on its way to Birkdale station and Waterloo Road.

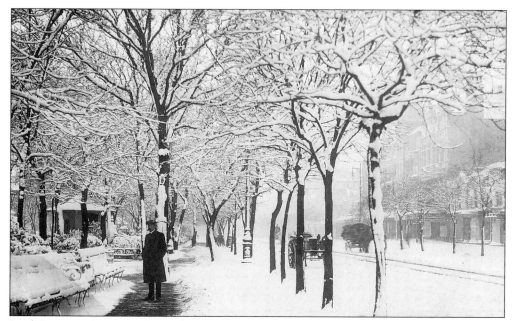

Lord Street under snow, December 1906. An exceptionally heavy fall of snow on Christmas Day and Boxing Day, backed by easterly winds, left the trees on the pavement outside Christ Church looking very picturesque.

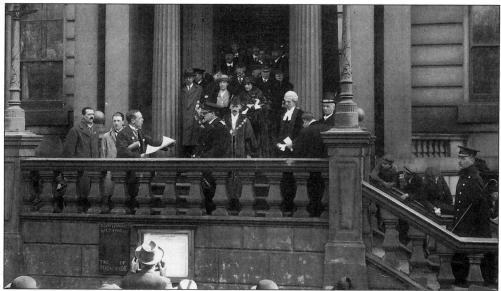

Admiral of the Fleet Earl Beatty, Southport Town Hall, 31 March 1919. The Mayor, Ernest Wood, and the civic ensemble witness the honouring of Sir David Beatty on the occasion of his visit to the town. Admiral Beatty, along with Field Marshal Douglas Haig, had been made a Freeman of the Borough in the previous month. Beatty Road and Haig Avenue commemorate the two Great War leaders. Below the balustrade can be seen the tide information board and the local barometer chart.

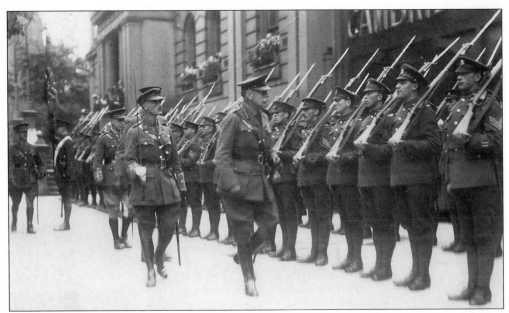

Field Marshal Douglas Haig, Southport Town Hall, 1919. On Monday 7 July, Douglas Haig visited the town and received the freedom of the Borough, granted him, and Admiral Beatty, five months earlier. He is seen here inspecting the guard of honour outside the Town Hall and Cambridge Arcade.

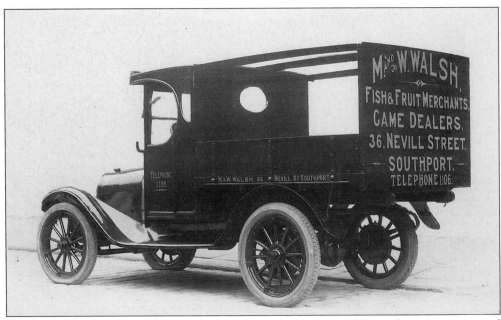

Walsh's delivery van, Nevill Street, 1914. The transition from horse-drawn to motorised delivery vans was an important advance for small shopkeepers, many of whom were quick to spot an opportunity for publicity by photographing their new mode of transport, replete with advertising details. Walsh's had just taken delivery of this vehicle.

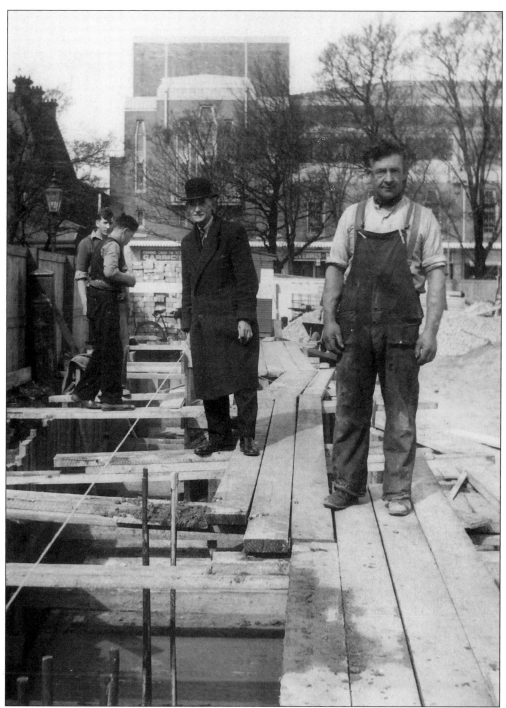

Construction of the Regal cinema, Lord Street, 1937. Built on the corner of Wellington Street, opposite the Garrick theatre, the Regal was opened on 5 December 1938. The feature film on that occasion was *Vivacious Lady*, starring Ginger Rogers and James Stewart. The workmen laying the foundations are under the watchful eye of building inspector James Brookfield. The building was demolished in 1987.

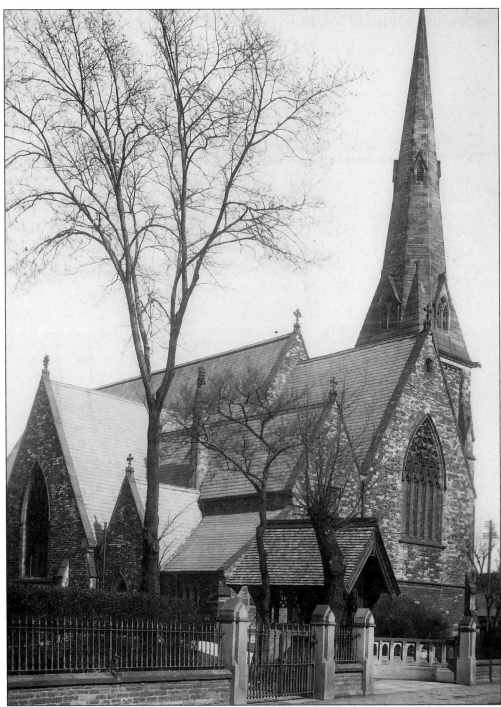

St. Andrew's church, *c.* 1922. In the summer of 1871 building began on the corner of Eastbank Street and Part Street, and on 17 June 1872 the church was consecrated by the Lord Bishop of Chester. The cost of construction was largely borne by William Atkinson, one of the town's notable benefactors. It is the Part Street entrance, with lych-gate, which appears in this photograph.

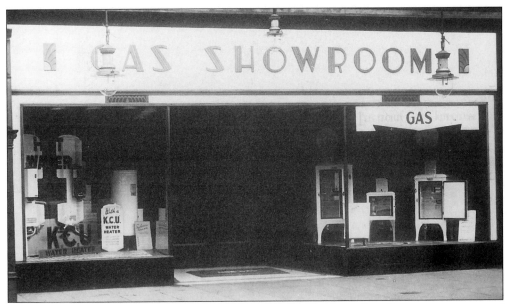

The Gas Showroom, Eastbank Street, 1930. The Corporation Gas Department attracted customers to 'one-hundred-per-cent clean-heat fuel' through its showrooms in the Cambridge Arcade and here at 91 Eastbank Street. Cookers, fires, water heaters, storage heaters, washboilers, refrigerators – all these and more could be purchased outright for cash or obtained on hire purchase terms. Interestingly, it was in Eastbank Street that the original Southport Gas Works began operations in 1850, before the new plant opened at Crowlands in 1872.

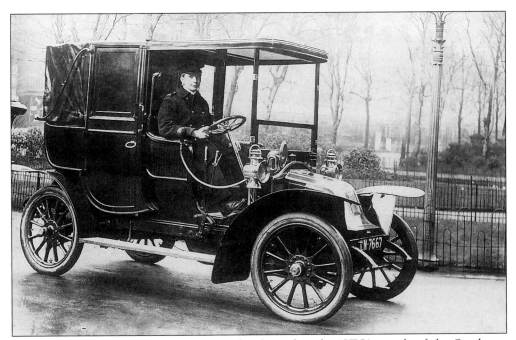

Motor car, Lord Street, February 1909. The driver has the 'STC' initials of the Southport Tramways Company on his epaulet. The photograph was taken in the gardens to the north-east of London Square, by the West End Studio of Scarisbrick Avenue.

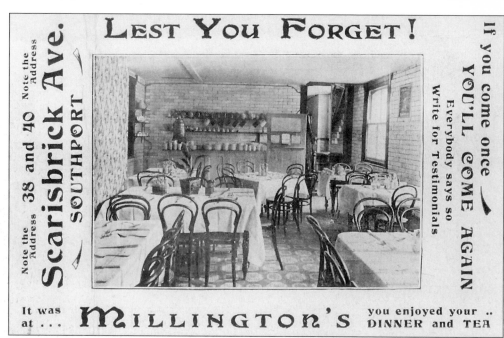

Advertising card, Millington's cafe, Scarisbrick Avenue, 1910. This is a nice period advertisement for Mrs. Emily Millington's 'Promenade' cafe. The establishment provided good plain breakfasts at sixpence each, best dinner at a shilling, and tea at ninepence. Rooms to accommodate 200 were available.

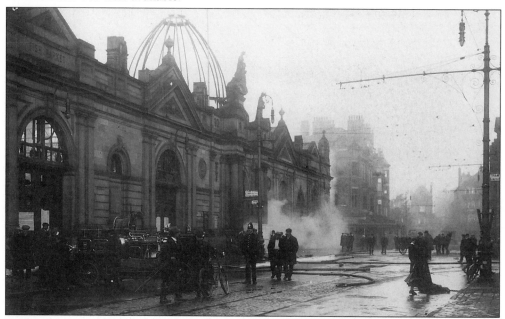

Eastbank Street market fire, 1913. This was the scene on Sunday morning 19 October, when damping down operations were still underway following the conflagration of the night before. The massive stone walls, ornamental carved figures and classical features made the market one of Southport's architectural treasures. The fire destroyed the building, which had opened in 1881, and left many uninsured tenants in crisis.

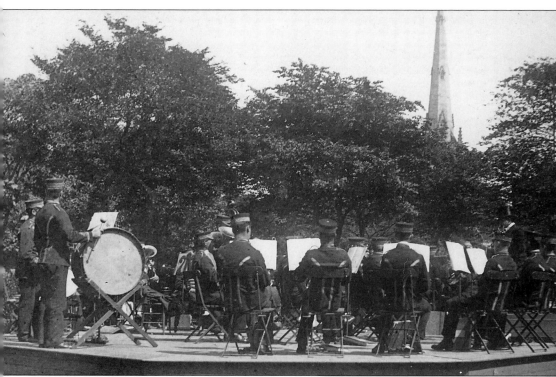

Corporation Band, Lord Street Gardens, *c.* 1876. Lawns, trees, a public seating area and a plain platform were the main constituents of the grounds opposite the Cambridge Hall when it opened in 1874. The area was developed three years later to include the first of two bandstands to occupy the site, but in the mid 1870's stirring music in relatively simple surroundings was the order of the day.

Junction of Lord Street and Leicester Street, 1941. The camera looks towards Leicester Street from the middle of Manchester Road. Tower Buildings can be seen on the left of the picture behind the Ribble bus, and the white sign attached to the disused tram standard on the right points to an air raid shelter for 100 persons.

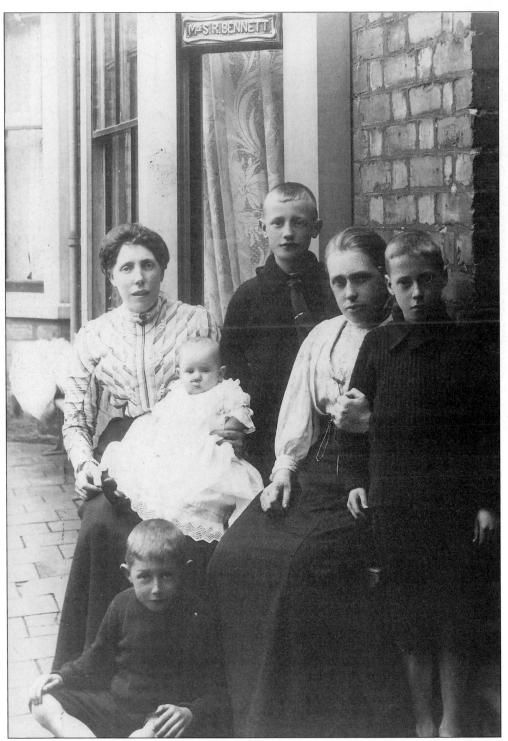

Holidaymakers, Moss Terrace, West Street, 1909. A group of visitors from Manchester are seen outside the holiday apartments of Mrs. Sidney Bennett of 74 West Street. The Moss Terrace alley still survives, close to Nevill Street.

London Square and London Street, 1912. There is plenty of detail in this interesting scene. The original cabman's shelter in the centre of the square has been demolished, and the much smaller former appendage (the urinal), now complete with high-tide times, coat-of-arms in stone relief, and enamel street sign, stands isolated. Parr's Bank building, built in 1892, overlooks the square, whilst on the other side of London Street in Exchange Buildings, is Greensmiths the shirt and pyjama manufacturer, and the Gospel Hall.

The Duke's Folly memorial lamp and Lord Street station, *c.* 1910. Anyone who is acquainted with the history of Southport will know that this memorial lamp was erected close to the spot where William Sutton, known as the 'Old Duke', built a shanty in 1792, which was to start the development of modern Southport. Behind the clock tower of the Cheshire Lines railway station stands the Opera House, and beyond that is Woodhead's Garage and the tower of Pavilion Buildings.

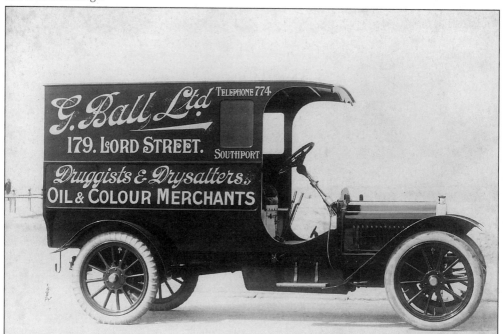

G. Ball's delivery van, 1914. The firm was taken over by Ambrose Richards shortly after the Great War, and continued in business until August 1958. The wages accounts show the last half dozen or so staff leaving or retiring.

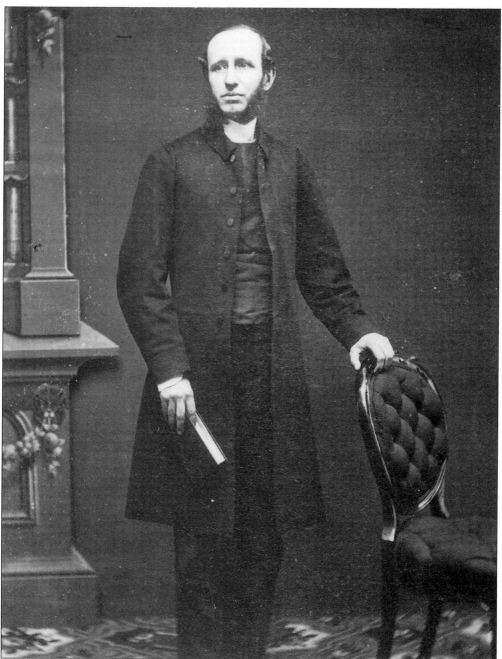

Reverend B.S. Clarke, vicar of Christ Church, 1862. Born and educated in Dublin, Benjamin
Strettel Clarke was only twenty six years old when he became the second vicar of Christ
Church in 1849, in succession to the Reverend William Docker. He arrived from the living in
Thorpe Hesley in the West Riding of Yorkshire, and remained at the church for forty six years
until his death in 1895. During this period he saw Southport grow, mature and prosper at an
astonishing rate, with the population rising from a meagre 5,000 to about 50,000. Benjamin
Clarke was a great scholar who was appointed to several important positions within the church
including, in 1887, Archdeacon of Liverpool.

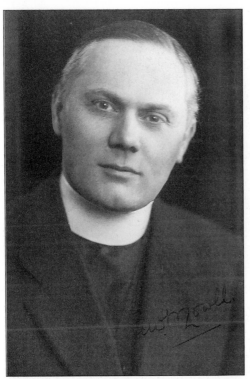

Reverend E.W. Mowll, vicar of Christ Church, 1921. Edward Worsfold Mowll came to Southport in 1919 from Newcastle, where he had been vicar of Benwell. He presided over the church's centenary in 1921 and left in 1927 to take a rectorship in Oxford. He later became Bishop of Middleton, and died in 1965.

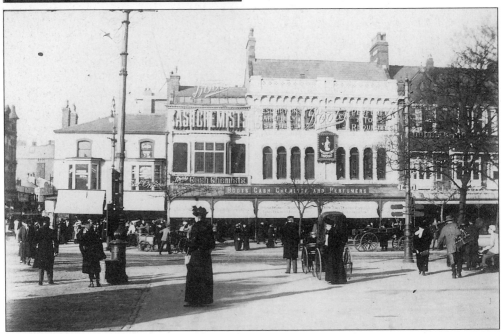

London Square, c. 1902. Boots Cash Chemists shop dominates this view across Lord Street from outside Parr's Bank building. At the extreme left of the picture, Nevill Street can just be seen. Although there are plenty of folk going about their business, the long shadows, bare trees, and heavy clothing indicate a winter's day. The scene on a corresponding summer's day would be far busier, with the centre of Southport crowded with visitors.

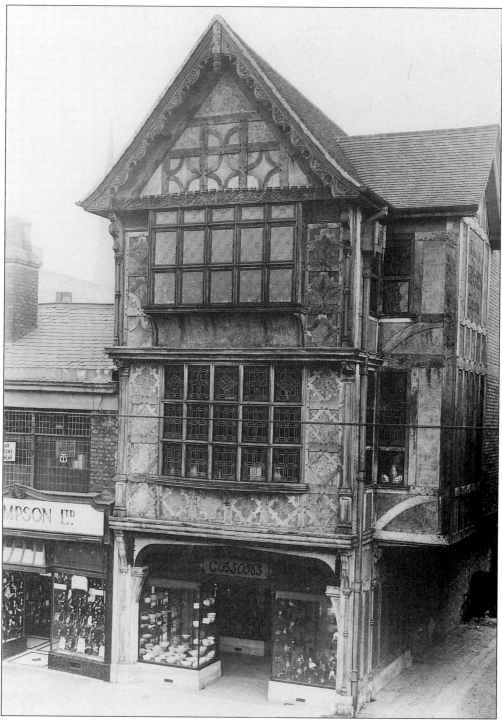

Gibson's Tudor House, Chapel Street, 1930. This splendid mock-Tudor building might easily pass for the real thing were it not for the fact that Chapel Street's development did not start until the 1830's. Thomas Gibson, for many years the shop proprietor, sold glass and china. A tram wire bisects the picture, but it is scarcely distinguishable against the building lines.

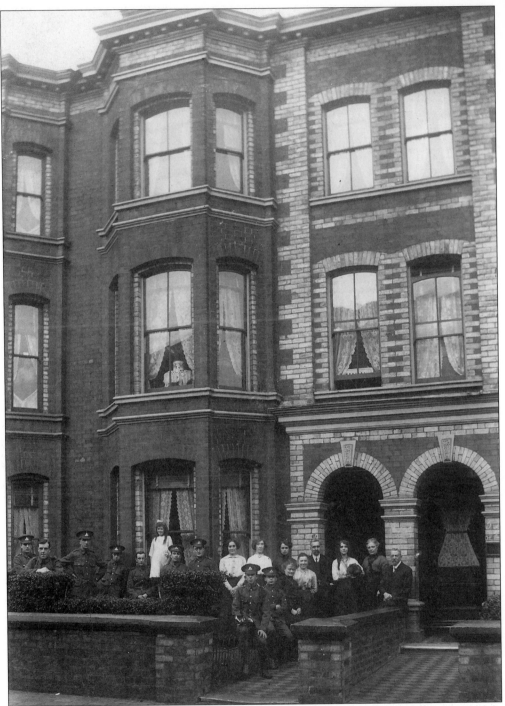

Soldiers in Victoria Street, *c.* 1916. Southport witnessed a huge influx of soldiers during the Great War. Among these were men recovering from injury in the various hospitals, and thousands who were billeted in the town. This group, at the front of 14 Victoria Street in the heart of the holiday apartment area just off the Promenade, includes two very young lads, one of whom is holding a bugle.

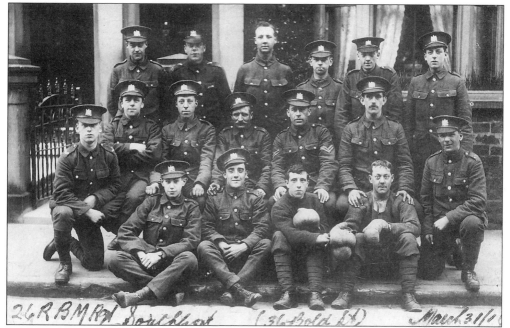

Soldiers in Bold Street, March 1916. Their names and, sometimes tragic, experiences are noted herewith. Back row, left to right: Kershaw (wounded), Charlton, Fitton, Whybrow (seriously wounded), Dawson (seriously wounded), Holgate (died of wounds). Middle row: Price, Collinge (missing), Eastwood, Taylor, Thomas (discharged), Vaughan (killed), Marsden (missing). Front row: Holland (wounded), Glynn (killed), Miller (wounded), and a second Kershaw. In the doorway, barely visible, is Tom Mills.

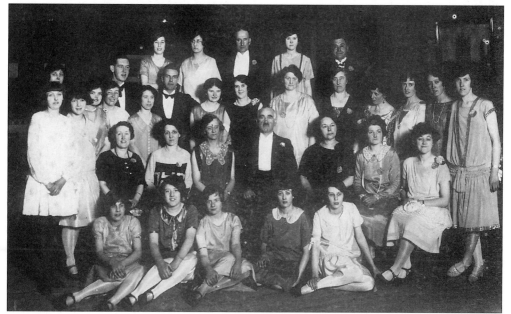

Woodlands Night School soirée, Cambridge Hall, 1926. Seated centre is Mr. Charles Thompson, elocution and music teacher, on the occasion of the soirée organised by the school's refreshment committee. The venue is the Cambridge Hall ballroom.

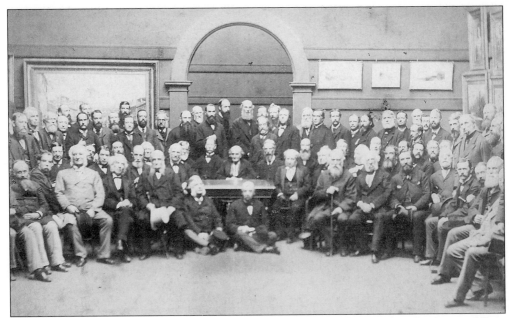

British Association meeting, Atkinson Art Gallery, 1883. Arthur Cayley, Professor of Pure Mathematics at Cambridge University, presided over the 53rd meeting of the British Association for the Advancement of Science, which was held in Southport from 19 to 27 September. Meetings, lectures, excursions and soirées filled a busy programme for the gathering of many of Britain's top scientists. The Professor is seated centre, behind the table.

Lord Mayor's Sunday, Town Hall, 1911. The procession waits outside the Town Hall and Cambridge Hall in readiness for a trumpet fanfare and departure. The Mayor, Charles Austin, a cotton merchant living in Cambridge Road, is not actually visible in the photograph, but his entourage makes an impressive sight.

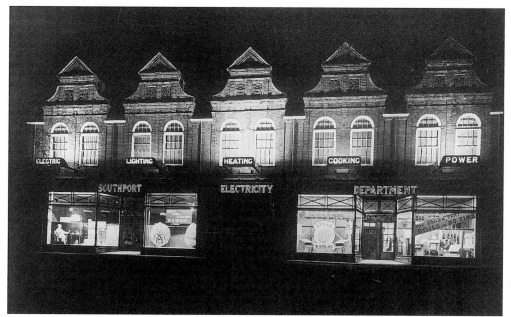

Southport Electricity Department offices and showrooms, Lord Street, 1928. Glaciarium Buildings, opened in 1879 to provide ice skating and related pursuits, had a rather varied existence until the Corporation decided to convert the premises into electricity showrooms in the mid 1920's. The building, looking impressive here with the upper portion floodlit, was at the north end of Lord Street next to Manchester Road, but is now demolished. Southport's first public supply of electricity was in 1894.

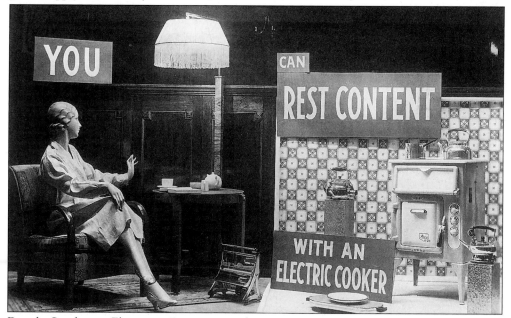

Detail, Southport Electricty Department showroom, Lord Street, 1928. The interesting selection of gleaming electrical equipment in the showroom window gives an idea of what was desirable and available at the time, although a single bar electric fire would not be considered in quite that way today. The electric kettle, however, has stood the test of time.

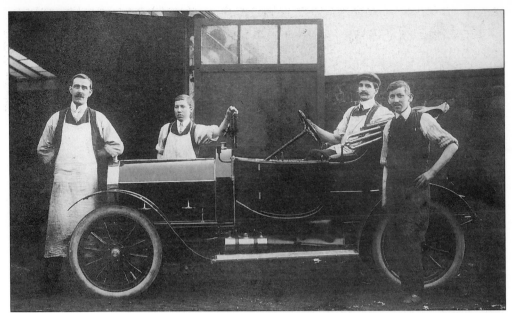

Messrs. Jackson and Kinnings, with staff, Ribble Motor Works, Eastbank Street, 1907. As well as Vulcan Motors, Southport was home to several other motor vehicle manufacturers in the early years of the century. One of these was Ribble Motors, started in 1903 by Jackson and Kinnings at 113 Eastbank Street. Ribble lasted until 1912, making motor tricycles (tricars) as well as four-wheeled vehicles.

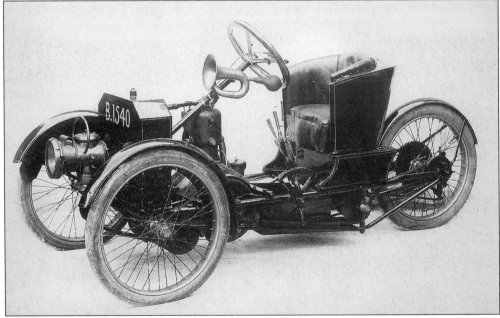

Jackson and Kinnings tricar, 1906. This gleaming machine, an eight horse-power vehicle weighing just 4 cwt, had just been built at the works in Eastbank Street. It carries a Lancashire registration plate, although Southport's 'FY' letters had been introduced on 1 September the previous year. The photograph was taken by Richard Gresswell, whose studio was at 131 Eastbank Street.

The Palladium, Lord Street, 1915. Built in 1913 on the site of Haughton House, a Victorian villa, the theatre opened on 3 January 1914. Marie Lloyd and Little Tich were among the many variety artistes who appeared on stage in the early years. A combination of live entertainment and cinema pulled in the crowds, but disaster struck in 1929 when the auditorium was destroyed by fire. The theatre re-opened the following year, and shortly afterwards films took over almost exclusively. Lamentably the building was demolished in 1980.

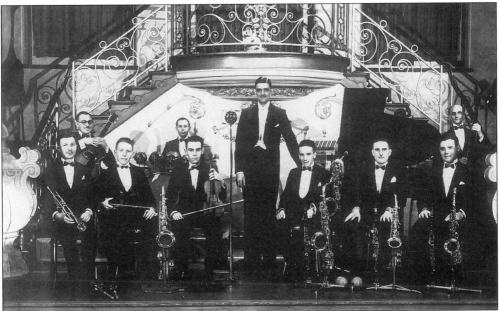

Jack Hunter and his band, Prince of Wales Hotel, 1937. Dinner dances were held each Saturday night in the Louis XV ballroom to the music of Jack Hunter's band. The ballroom, pictured here, was unique, with its splendidly sprung floor, beautiful balcony, charming foyer and variety of lounges through which the dancers could roam at will – at least that was how it was advertised at the time.

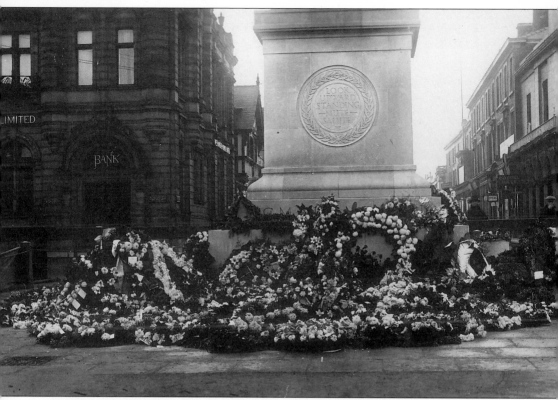

The War Memorial, London Square, 1923. The base of the obelisk is covered with wreaths following the unveiling ceremony on Sunday 18 November. Carved into the Portland stone are the final words of Barry Pain's Armistice Day poem *The Army of the Dead*: 'Look upward, standing mute; Salute'. Together with the pair of colonnades which contain the cenotaphs, and the water gardens, the $67\frac{1}{2}$ feet high obelisk ranks as one of the finest war memorials in the land. It tends to be taken for granted these days with its scale, design, inscriptions, carvings, and overall aestheticism being lost in the noise, pace and pollution of modern town life.

Five

Promenade
and Sea Front

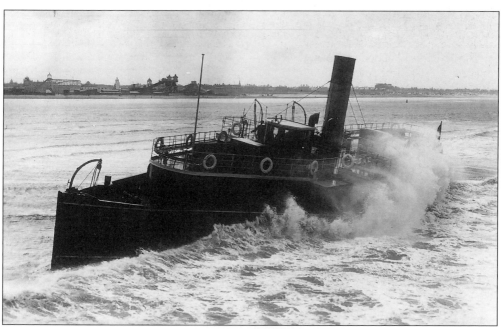

Ribble Queen, aground off the pier, 1925. The paddle-steamer started her career on the River Mersey, sailing between Liverpool docks and the entrance to the Manchester Ship Canal. She then went to Ireland and saw service as a ferry steamer between Greenore and Warrenpoint on Carlingford Lough. J. Gale and Company of Preston purchased her in 1922, registered the name *Ribble Queen*, and operated her between Preston, Lytham, St. Anne's and Southport for a few short years. She is seen here after breaking loose in a gale, after which she was stranded on a sandbank for over five weeks.

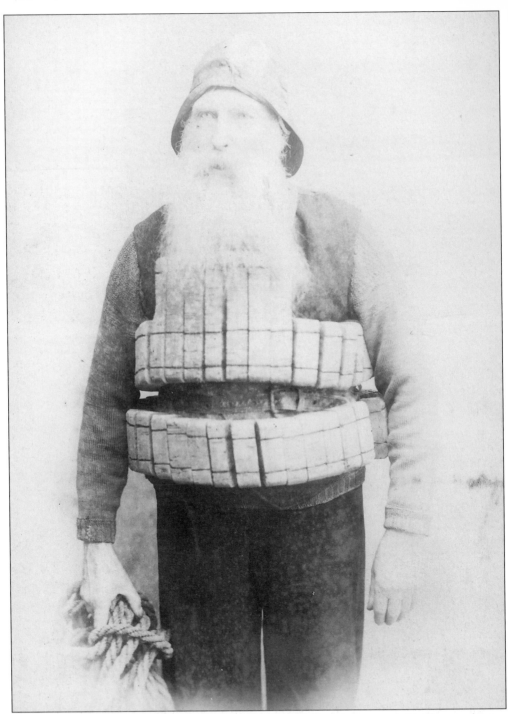

William Bibby, lifeboat man, *c.* 1880. Hundreds of vessels have come to grief in the treacherous shallow waters, riddled with sandbanks, just off the Southport coastline. In response to the potential and actual human tragedy, many volunteers have manned the various lifeboats with courage, bravery and consistency, perhaps none more so than William Bibby, who was connected with the Southport lifeboat for over fifty years.

Marine Drive, 1910. The development of the foreshore area was a matter of much concern and activity from the moment the Council decided, in 1886, to create a marine park and lake. As the scheme evolved, a Marine Drive was built which enclosed the South Marine Lake and provided a most bracing walk, or drive, from and back to the Promenade. It was not always a dry experience, as can be seen from the next picture.

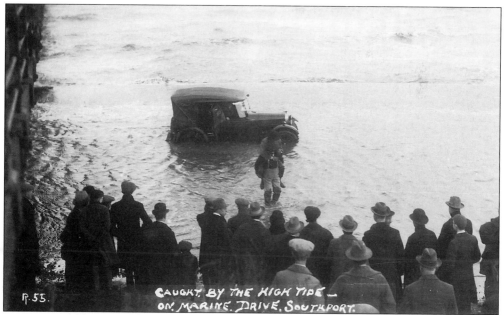

Marine Drive flooding, 1926. A stranded motorist, with his passengers, is relieved to be rescued on a fisherman's shoulders from the high tide alongside the pier. The fashions of the day dictated the wearing of hats, and all but one of the twenty-five or so onlookers are dressed thus.

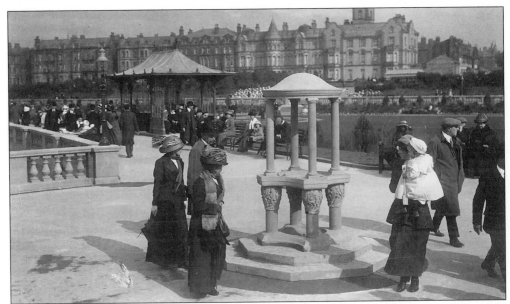

King's Gardens, 1913. Created on the site of the old foreshore fairground, King George V opened the gardens on his visit to Southport on 8 July. The message on this postcard reads, 'This is a view of the King's Gardens which he opened on Tuesday. It was quite a gay day, fireworks at night and a carnival on the lake – the boats were a treat'.

Ladies outing, South Promenade extension, c. 1931. These fashionable members of the Longford Park Ladies Bowling Club in Stretford are making their way towards Rotten Row, over the bridge spanning the approach to Lord Street railway station. On the extreme right is the Kingsway cafe which opened in April 1930, with seating accommodation for over 2,500!

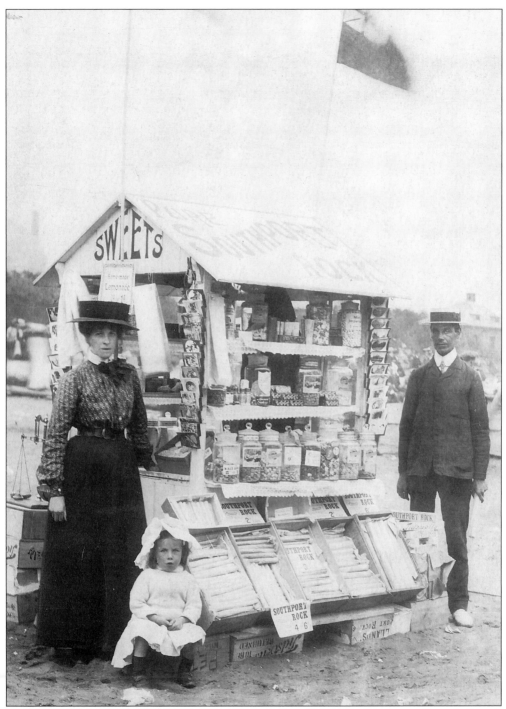

Sweet stall on the fairground, 1910. This wonderfully presented temporary stall, packed with
sweets, lemonade, postcards and variously priced Southport rock is, no doubt, sheer heaven to
the little girl sitting by it. Out of view are other stalls and amusements belonging to the old
fairground. Note the wooden boards crossing the sand to aid walking, and the brass scales
behind the lady.

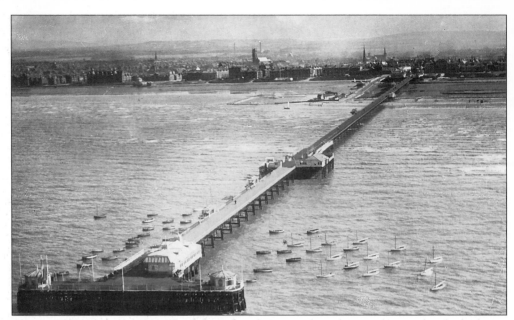

The Pier from the air, 1918. The fishing fleet lies at anchor close to the pier head which was destroyed by fire in July 1933. When this photograph was taken, paddle steamers still kept up a regular service, but channel silting brought this to an end in the 1920's.

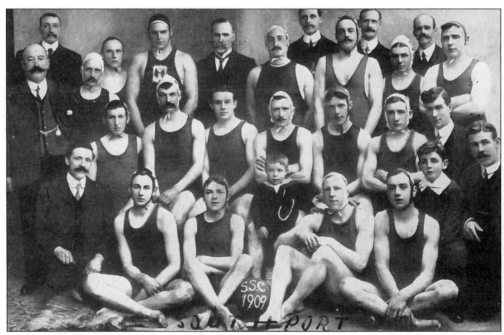

Southport Swimming Club, 1909. This postcard was posted in March 1911 by a club official, A.H. Bebbington of 31 Bold Street, to arrange a fixture against Weston-Super-Mare. It reads, 'I am agreeable to July 31 for our fixture at £9-0-0d, subject to being able to arrange another date or two so that we can somewhere near cover expenses.'

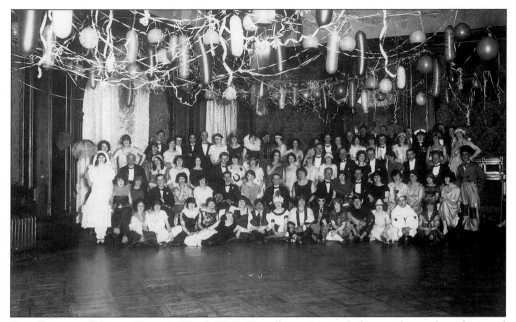

Broadbents staff dance, Queen's Hotel, 1923. Broadbents Limited, drapers, house furnishers and funeral directors, was for many years Southport's premier store, occupying extravagant, turreted premises on the corner of Chapel Street and Corporation Street. Christmas 1923 saw the staff resort to the Queen's Hotel on the Promenade to enjoy their fancy dress party and dance.

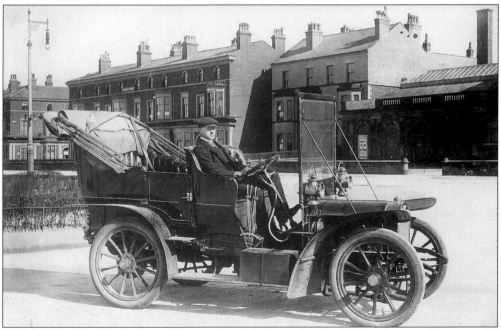

Motoring on the Promenade, 1907. The proud owner of one of Southport's early motor cars poses at the entrance to the Marine Drive in the late autumn of 1907. The Turkish and swimming baths are visible on the right, and Stanley Terrace is left of centre next to Victoria Street.

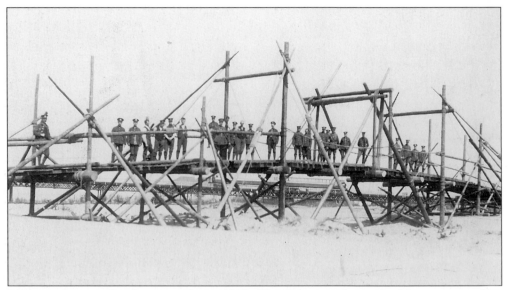

Military exercise, Southport sands, *c.* 1917. The large numbers of soldiers quartered in Southport during the Great War spent part of their time carrying out routines and practices. The expansive beach was ideal for exercises such as building temporary bridges in double-quick time, and no doubt dismantling them even faster. Here, the soldiers pause for breath on completing a reasonably sturdy looking structure, and to have their photograph taken by William Findley, who had studios at the fairground and in Shakespeare Street.

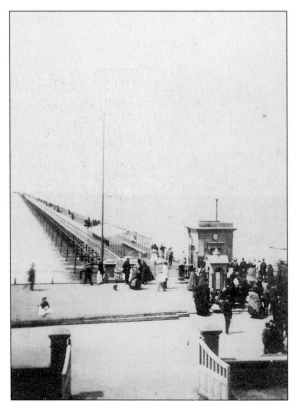

The Pier, 1862. Opened with great ceremony on 2 August 1860, the original pier took twelve months to construct. In this view it is relatively undeveloped, being without the tramway introduced in 1863, and devoid of the entrance buildings added in the late 1860's. The Fernley drinking fountain (see next picture) is prominent in the foreground. The photograph was taken from the first floor of the Victoria Hotel, by Henry Sampson.

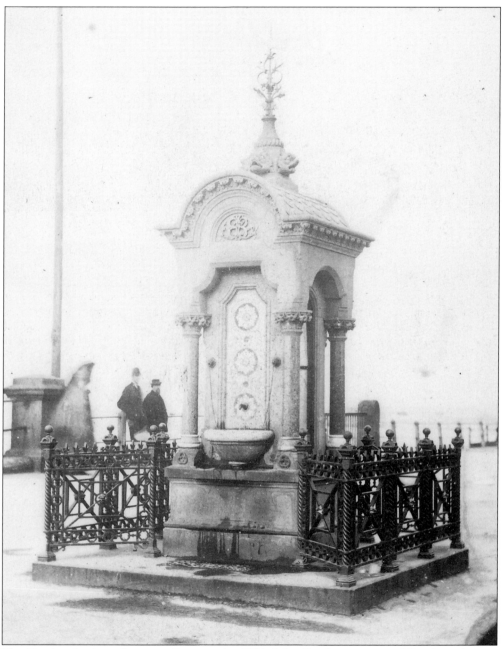

The Fernley drinking fountain, Promenade, 1861. John Fernley was one of Southport's most generous benefactors. Born in 1796, he was a wealthy businessman by the time he moved to Southport from Manchester in the late 1850's. He built Clairville in Lulworth Road and resided there until his death in 1873. As well as this magnificent drinking fountain, incorporating a barometer, which he presented to the town in July 1861, he provided capital for the building of Methodist churches, a meteorological observatory, an astronomical observatory, an infirmary and for the purchase of a new lifeboat, named after his wife Eliza. The *Eliza Fernley* became known the length and breadth of the land when it was lost in the great lifeboat disaster of December 1886.

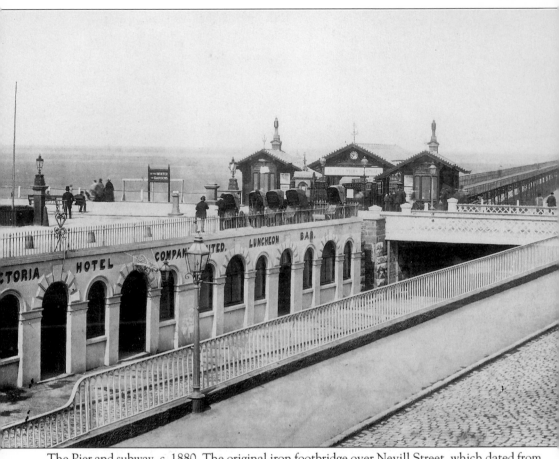

The Pier and subway, *c.* 1880. The original iron footbridge over Nevill Street, which dated from 1839, was replaced by the wider bridge seen here when the pier was constructed in 1860. It allowed carriages to pass uninterrupted along both the northern and southern stretches of the Promenade. Entry to the vaults and luncheon bar of the Victoria Hotel was gained from the subway leading to the sands.

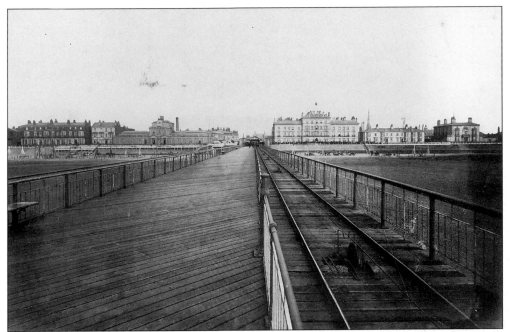

The Pier, *c.* 1880. This is an excellent study of the pier tramway cable traction. The north and south lakes have not yet been formed, and steps lead directly down from the Promenade to the sands. The pier entrance is framed by the Victoria Baths and the Victoria Hotel, to the right of which the spire of Christ Church is visible.

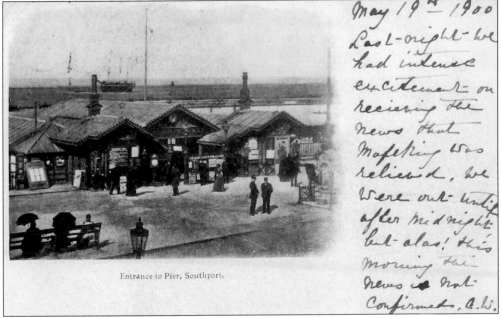

May 19th 1900
Last-night we had intense excitement on recieving the news that Mafeking was relieved. We were out until after midnight but alas! this morning the news is not confirmed. C.W.

Entrance to the Pier, *c.* 1899. This postcard view has alongside it an interesting communication about the celebrations following the relief of Mafeking, which occurred on 17 May 1900. The message, sent to a young lady in Switzerland, is dated 19 May and refers to the rejoicings of the night before, so word from South Africa had certainly spread quickly.

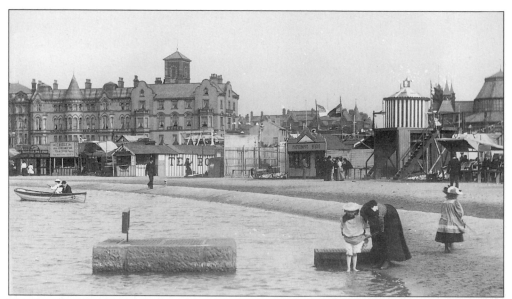

The Fairground, 1895. A little girl has her dress re-arranged in preparation for a paddle in the South Marine Lake. Photographic studios and refreshment bars feature strongly in this quarter of the lakeside attractions, against a background dominated by the Royal Family Hotel. This was the year when the south and north Marine lakes were joined.

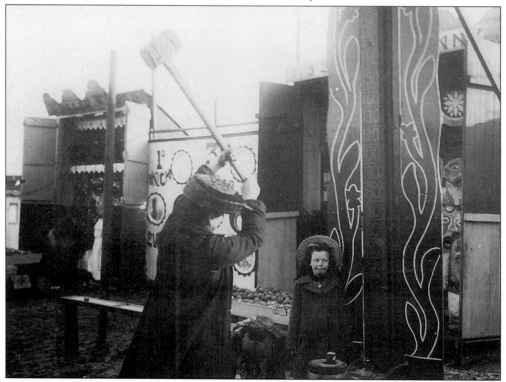

The Fairground, c. 1900. This juxtaposition of a lady testing her strength with her daughter standing close by was surely intended to create this amusing effect, but who knows? These side stalls were located on the lower sands, before the creation of King's Gardens.

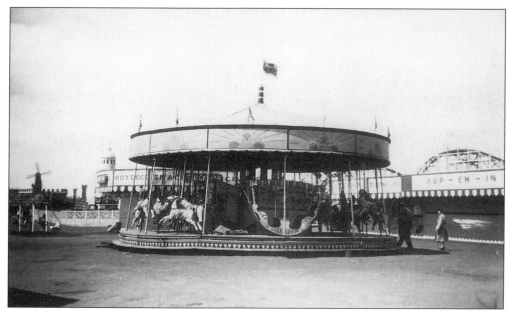

The Fairground, July 1950. This traditional attraction of galloping horses cost sixpence a ride for all classes. Although the austerity of the post-war years was still felt, it scarcely explains why so few pleasure seekers were in evidence on this fine Saturday in mid-July.

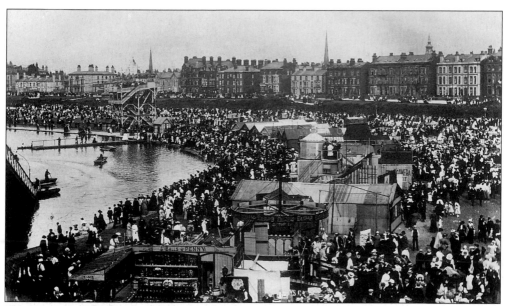

The Fairground, 1905. In stark contrast to the 1950 view, these August bank-holiday crowds of forty-five years earlier are simply swarming around the amusements. It was because of the noise and disturbance that accompanied scenes like this that the fairground was eventually removed from the Promenade area to its present site closer to the shore.

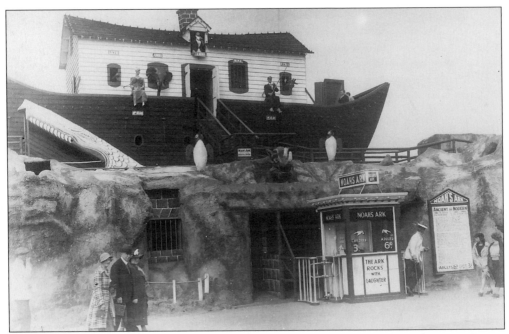

The Fairground, 1936. This is Southport's famous Noah's Ark, with resident characters Lizzie, Jumbo, O.U. Noah, Mike, Ezra, Mrs. Noah and Ham keeping watch over proceedings. The entry charge was sixpence for adults and threepence for children.

The Winter Gardens, c. 1885. Built in 1874 at the Birkdale end of the Promenade, this imposing complex was never to achieve its true potential. Ambitious in the range of entertainments it offered, its early years of excitement and optimism eventually gave way to financial difficulties, lack of support and decay. An interesting incident occurred in December 1909 when a speech by Winston Churchill in the main hall was loudly interrupted by suffragettes who had hidden in the building beforehand, and for several minutes there was a state of high disorder.

Six
Birkdale

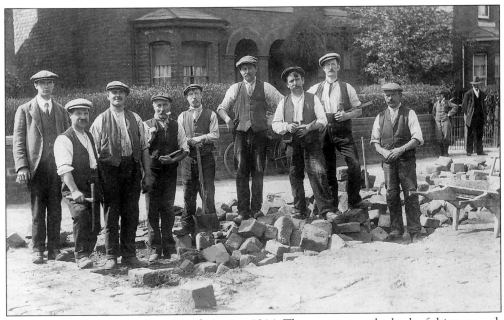

Road menders, Upper Aughton Road, August 1914. The message on the back of this postcard, written from 102 Upper Aughton Road, complains of the time being taken to complete the road repairs: 'this is the 3rd week'. It was all down to the gaffer, standing left, presumably.

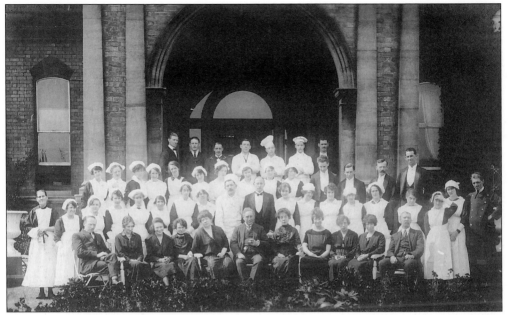

Palace Hotel staff, May 1921. The hotel's various operations are well illustrated by the uniforms of the fifty employees gathered round the general manager. The hotel dates from 1866, but is now demolished.

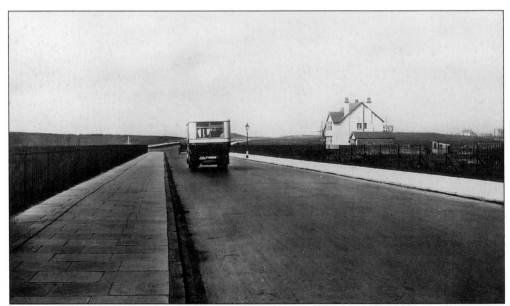

Waterloo Road, *c.* 1923. The view here, looking towards Southport from the road bridge over the railway line to Liverpool, looks quite empty, with the housing development seen today scarcely begun. Moreover, Hillside station wasn't yet open (it was built in 1926 to cater for the growing number of residents). A Corporation single deck bus, of Vulcan manufacture, heads into town from Woodvale over the highest ground in Southport.

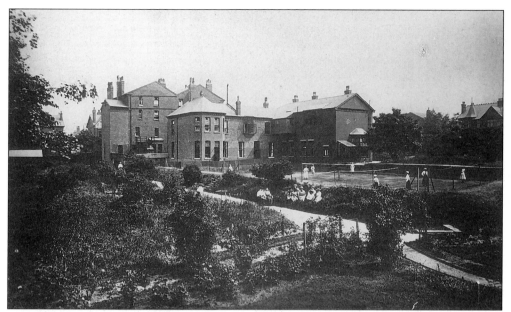

Wintersdorf school, Trafalgar Road, 1909. This school for young ladies, then in the charge of the Misses Simon, was located on the corner of Regent Road. The gardens are typical of the extensive grounds behind many of the villas in Birkdale Park, often being large enough to contain croquet lawns or tennis courts.

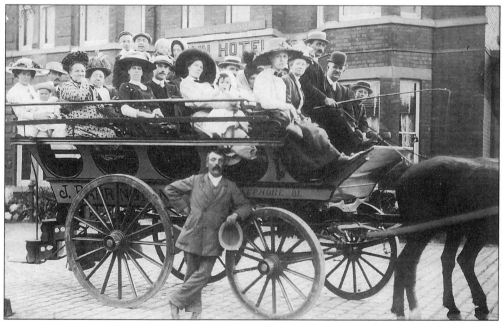

Coaching party, Crown Hotel, c. 1906. This is one of John Barrington's wagonettes, packed with trippers. He became proprietor of the Southport and Birkdale Carriage Company, which in a later existence became Gore's, famous for their motor coach tours.

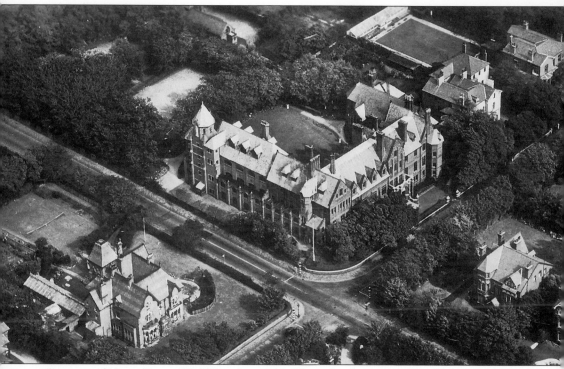

Convent of Notre Dame, Weld Road, c. 1948. This school was one of eighteen established by the Sisters of Notre Dame in England. The building dates back to 1878, but other, much smaller, premises existed in Birkdale during the preceding decade. The first verse of the school song reads thus:

Strong and sure stands our home of childhood,
Notre Dame in the dear west land,
Where the red tower firmly rises
Over the seas and shifting sand,
With its upward finger marking
Where our childish feet have trod,
Teaching children past and present
That all schooldays lead to God.

Sadly the school, as well as the magnificent Victorian villa seen at the bottom left, on the other side of Lulworth Road, has been demolished.

108

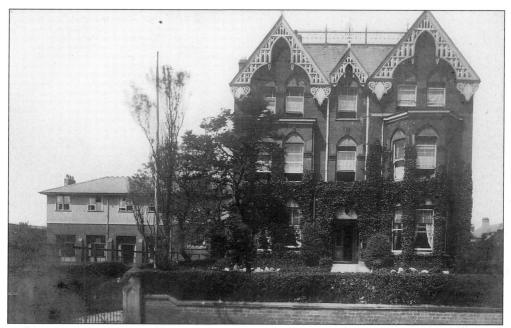

Birkdale Ladies' College, Malvern House, Waterloo Road, 1911. The college, with its ornate roof boarding, stood on the shore side of Waterloo Road close to the junction with Grosvenor Road. The building on the left is the new wing, rising from the back of the tennis courts, which was erected in 1906.

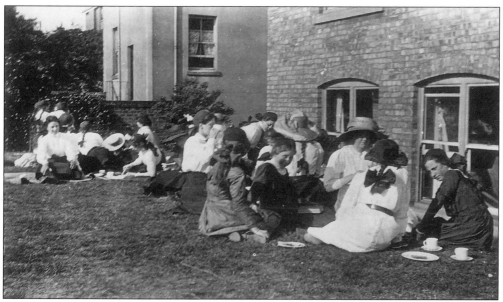

Girls having tea in the garden, Birkdale Ladies' College, 1911.

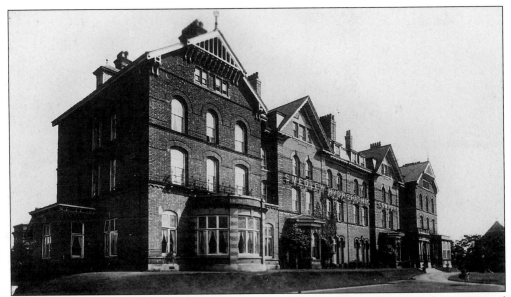

Smedley Hydropathic Establishment, Trafalgar Road, 1910. The hotel opened in 1877 and provided various health facilities in such pleasing surroundings as are illustrated in the following photographs. A range of baths, including Turkish and Russian, were opened daily to the public. The name 'Smedley' refers to the gentleman who had opened a very successful hydropathic centre in Matlock, Derbyshire, the style of which Birkdale followed.

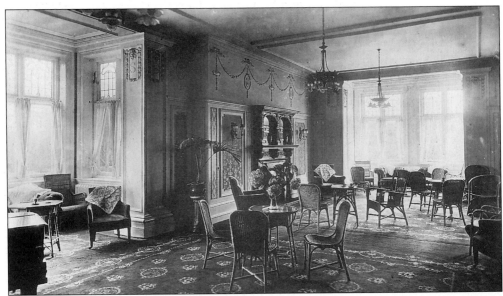

The lounge, Smedley Hydropathic Establishment, Trafalgar Road, 1910. Mr. Smedley's initial 'S' is evident in the ornate plasterwork high on the lounge walls.

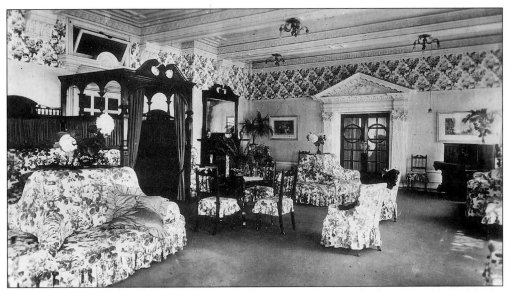

The drawing-room, Smedley Hydropathic Establishment, Trafalgar Road, 1910. Another view of the well-appointed interior. It was clean, light and comfortable, but fell short of sumptuousness.

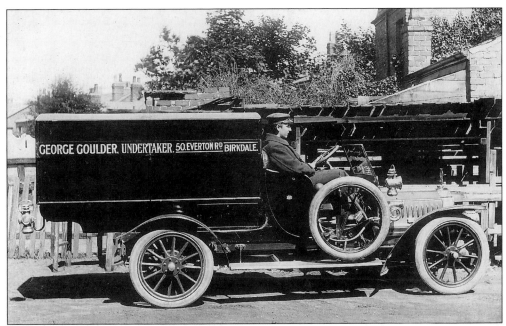

George Goulder, Everton Road, 1910. Founder of the well-known firm of Birkdale undertakers, George had five children, two of whom became involved in the business. It was George's grandfather who established the livery stables which were eventually to become Goulder's Motors, trading in Weld Road today.

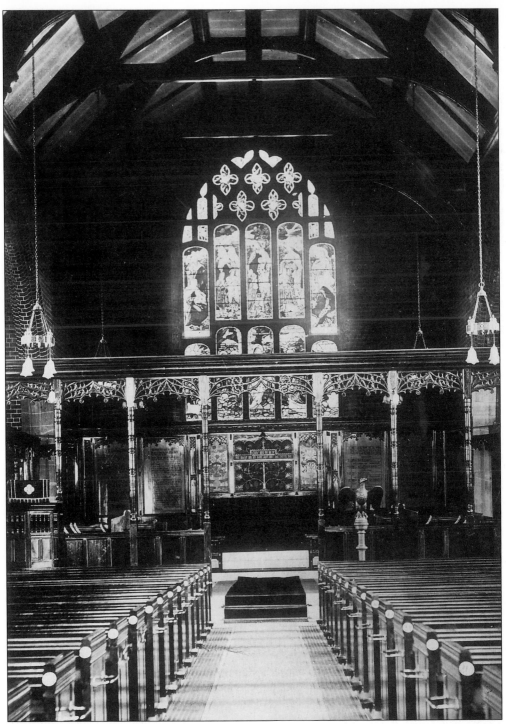

St. John's church, Birkdale, c. 1924. Situated just off Liverpool Road, in St. John's Road, the church originally served as a chapel-of-ease to St. James'. Building began in 1889 and the first service was held in December the following year. The church wasn't finally completed until a north aisle and vestries were added in 1910, following a substantial bequest of £1,000.

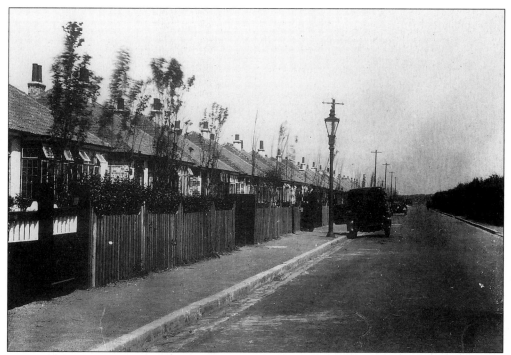

Moss Road, 1939. These modest bungalows were built in the early 1930's on the far side of Sandy Brook, and are therefore in the township of Halsall. Nevertheless, residents and observers generally consider this stretch of road to be part of Birkdale, as it contains the last of the housing beyond Stamford Road before the open moss is reached.

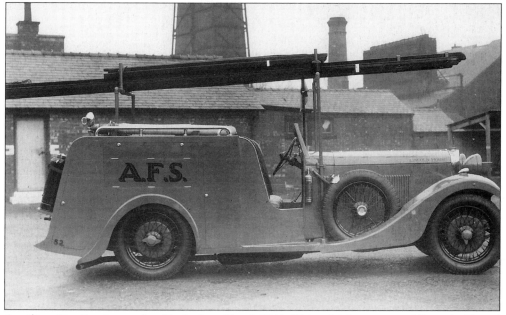

Auxiliary Fire Service tender, Shaftesbury Road, 1941. This vehicle was named 'Lincoln House' after the children's home bearing that name in nearby Lincoln Road. It is pictured at the Shaftesbury Road Electric Supply Works.

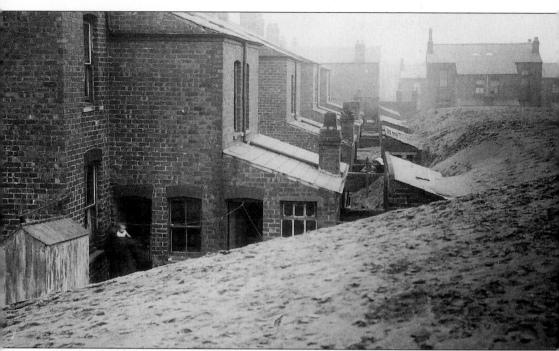

Sand encroachment, Upper Kew Road, c. 1900. Sand dunes are a familiar sight along the coastal strip, but for many years they also featured further inland. A significant accumulation existed in the area now occupied by Bedford Park, and it is here that this spectacular scene was photographed. The conditions must have been difficult for the residents, especially on windy days. The houses near the top of the picture are in Boundary Road (now Guildford Road).

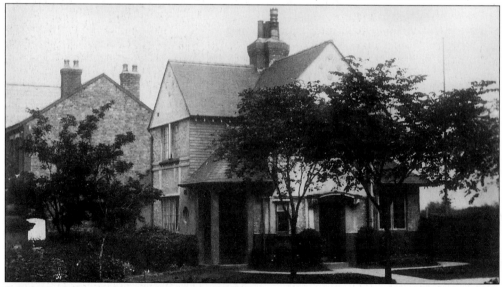

Entrance and Lodge, Bedford Park, c. 1925. The eyesore and inconvenience which was the sandy wasteland seen in the previous picture had disappeared twenty-five years on. Landowner Charles Weld-Blundell gave the land to Birkdale Council in 1909 (before amalgamation with Southport), and Bedford Park was created. Harold Holden was the park keeper at the time of this photograph.

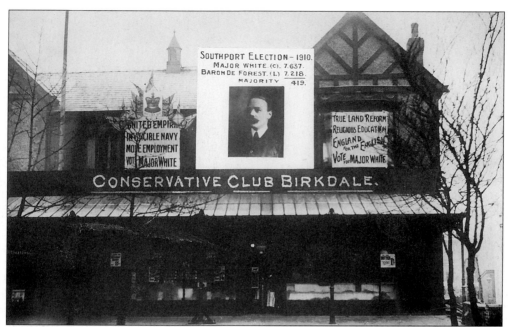

Birkdale Conservative Club, Liverpool Road, 1910. Situated close to Birkdale railway station, the Club prepared for the General Election of 24 January by proclaiming its views to passers-by, including the slogan 'England for the English' – a reference to the European blood in Baron De Forest, the Liberal opponent. In the event, the Conservative candidate, Major G. Dalrymple White, won a narrow majority. The result is seen here on a superimposed photograph. The protagonists are seen in the following photographs.

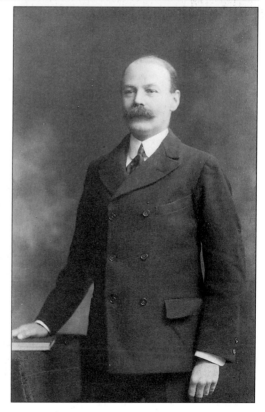

Major Godfrey Dalrymple White, 1910. Having won the seat for the Southport Division in January 1910 with a majority of 419, Major White went on to increase his majority in the General Election of December that year, before becoming the first Member of Parliament for the Borough of Southport in December 1918, following Parliamentary review. He was made a Freeman of the Borough in 1932. His father, Sir Henry, was a commander in the Crimean War at Balaclava, famous for the Charge of the Light Brigade.

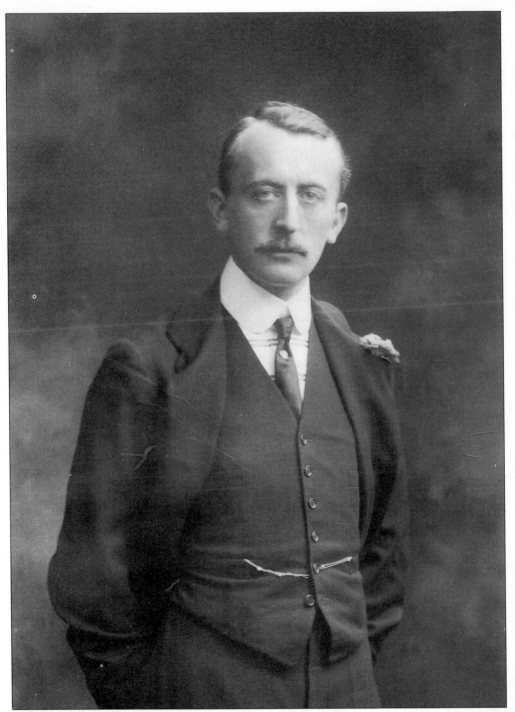

Baron De Forest, 1910. After narrowly losing the first of the two General Elections in 1910, Baron De Forest never fought the Southport seat again. However, there was plenty of support and warmth of feeling in his single campaign, as his advertising leaflets suggest. De Forest, an extremely wealthy man, later became Member for West Ham. He is photographed here by Richard Gresswell of Eastbank Street.

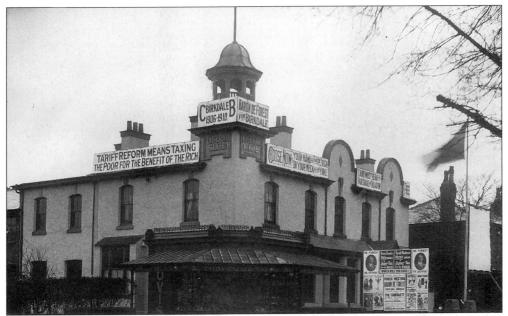

The Liberal Club, Liverpool Road, 1910. Round the corner from Birkdale Conservative Club was the Birkdale and County Liberal Club, on the corner of Bolton Road. The posters highlight the issues of the General Election, with Baron De Forest, the Liberal candidate, holding strong views about local land ownership and taxation. The initials 'CB' on the topmost poster refer to Charles Brumm, a Liberal notable and Consul for Haiti, who lived in Oxford Road. Thomas Coulton's bread shop is seen below the Club rooms.

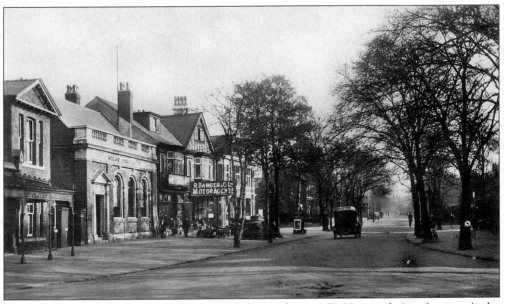

Liverpool Road, c. 1930. The traders, from left to right, are: T. Unsworth (confectioner), the Midland Bank, R.B. Gibson (ironmonger and radio dealer), R. Bamber (motor agent and garage, 150 cars in stock) and the Manchester and County Bank.

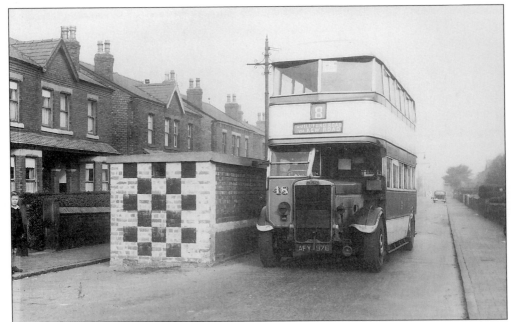

Air-raid shelter, Kew Road, 1941. The semi-detached houses on the extreme left of the picture are numbers 68 and 66 Kew Road. In front, the roadway is obstructed by a war-time emergency shelter. The bus lights are blacked out, and the shelter, along with roadside trees and street furniture throughout the borough, is marked to assist motorists in the absence of street lighting.

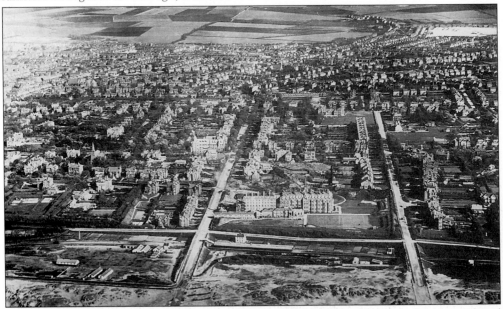

Birkdale from the air, 1918. The two prominent roads leading inland are Weld Road and Oxford Road. Situated between them is the Palace Hotel, in front of which, adjacent to the sand dunes, is Birkdale Palace station on the Cheshire Lines railway. The villas of Birkdale Park, in their spacious grounds, occupy the land on the shore side of the Lancashire and Yorkshire railway which stretches across the picture near the top, while inland of the line stands the more prosaic housing of Birkdale Common.

Seven
Ainsdale and Woodvale

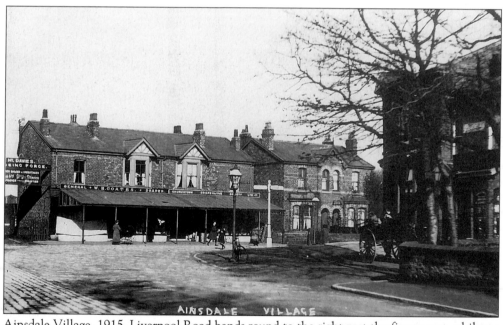

Ainsdale Village, 1915. Liverpool Road bends round to the right past the finger-post, whilst to the left, out of view, Station Road leads down, not surprisingly, to Ainsdale station. Under the veranda, a branch of the Churchtown Co-operative Society stands next to Coates' drapers shop, behind which is Henry Davies' multifarious business of blacksmith, coach-builder, joiner, undertaker and so forth.

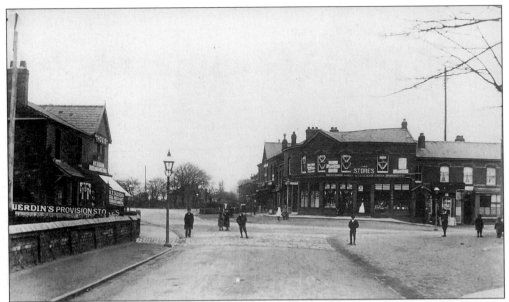

Ainsdale Village, c. 1908. Another view of the village, this time with Station Road in the foreground. Liverpool Road embraces the row of shops, featuring Duerdin's Stores, which faces the camera. The open frontage of the Railway Hotel is seen on the right, whilst children of all ages stand perfectly still for the benefit of the photographer.

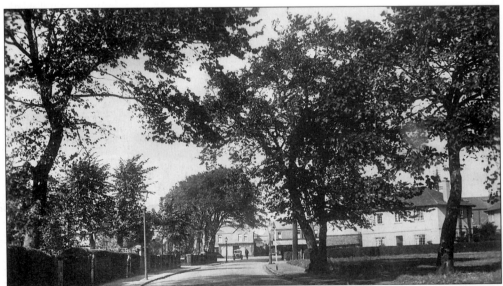

Liverpool Road, by the village green, c. 1930. Before Liverpool Avenue, with its new housing, became established in the early 1920's, this short section of Liverpool Road was part of the main thoroughfare. The tall, slim-style, gas street lamps on the left-hand pavement are positioned either side of Sanvino Avenue.

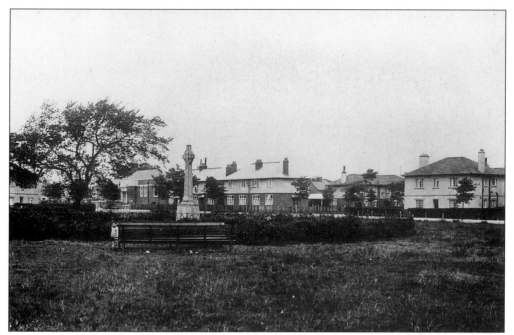

War Memorial and village green, *c.* 1932. The memorial commemorates the lives of forty-four Ainsdale folk, including one lady, who perished in the Great War. Houses built for those who returned safely are visible in Liverpool Avenue. The library of 1929 can be seen behind the little boy who is standing in the rather long grass.

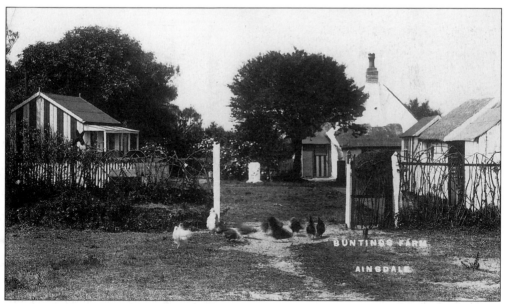

Bunting's Farm, 1914. The poultry farm was situated to the north of Pinfold Lane, between Liverpool Road and the Lancashire and Yorkshire railway line. At the time when this photograph was taken the small timber house on the left was offered as summer holiday accommodation.

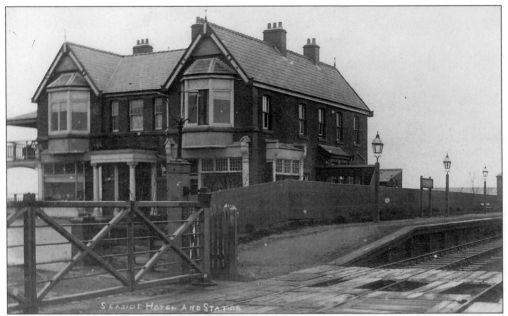

Seaside Hotel and station, 1910. The Southport and Cheshire Lines Extension Railway opened in September 1884, providing a route from Aintree to Lord Street station in Southport. The parent line (the Cheshire Lines Railway) supplied, in very broad terms, a service between Chester, Manchester and Liverpool, rather in the shape of a horse-shoe. Seaside station was opened on 19 June 1901, but was renamed Ainsdale Beach in 1911, and afterwards the hotel too changed its name, to the Lakeside.

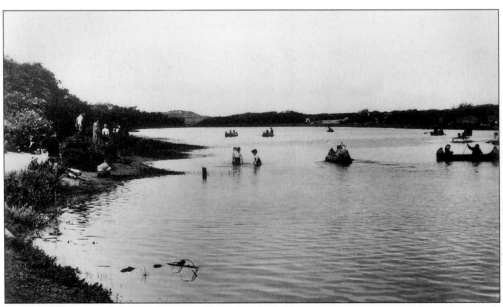

Boating lake, Ainsdale, 1949. As well as local children, many youngsters from the north Liverpool area have, over the years, enjoyed the pleasures offered by this artificial lake, so conveniently situated next to Ainsdale Beach station and the Lakeside Hotel.

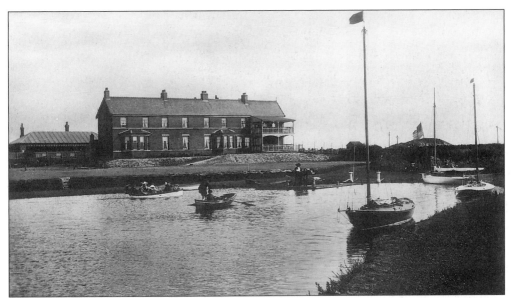

Boating lake and Lakeside Hotel, Ainsdale, 1918. An earlier view of the lake, this time showing the hotel and, at the extreme left, Ainsdale Beach station rooms. James Buckley was the proprietor of the Lakeside temperance hotel at this time, and it was he who published this postcard.

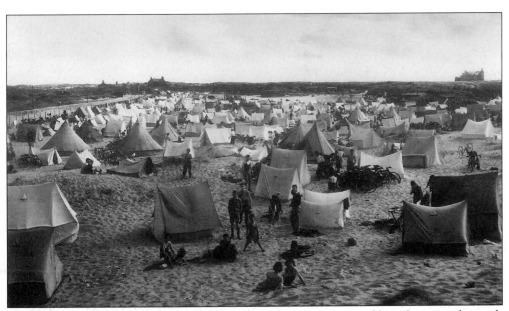

Camping near the Boating lake, Ainsdale, c. 1938. Scores of tents and bicycles cover the sands to the north of the lake. To the left of picture is the Cheshire Lines Railway leading to Ainsdale Beach station. Ainsdale was a resort in its own right, albeit on a small scale. It was popular with those who were content to find their own amusement, rather than pay good money for the commercial delights provided by Southport's central attractions.

Fancy Dress Ball, 28 February 1919. Richard Matthews and Ronald Hooton, appearing as Dilly and Dally, won first prize in the gentlemen's original dress section of a competition organised by the officers of the Ainsdale boy scout troop. The event took place in the Parochial Hall, and Dilly and Dally are seen beforehand, getting ready to win over the three lady judges.

124

Ainsdale Mill, c. 1918. Standing on the site of an earlier wooden mill, this sturdy structure was built about 1800, and withstood the elements and ravages of time until closure in 1965, and subsequent demolition. Shortly after the opening of the Liverpool, Crosby and Southport Railway, a branch line from Ainsdale station was constructed, in 1851, to serve the mill. A rail track can just be seen at the bottom of the picture, passing the mill doors.

Sacred Heart church, Liverpool Road, 1909. The proper address was Liverpool Road South in those days, the Birkdale portion of Liverpool Road ending at Clifford Road. The old boundary between Birkdale and Ainsdale was just a few feet to the left of the church, barely off picture, but on 1 April 1905 Ainsdale amalgamated with Birkdale, so making the boundary less significant. To the right of the church is the residence of the minister, Reverend Edward O'Reilly.

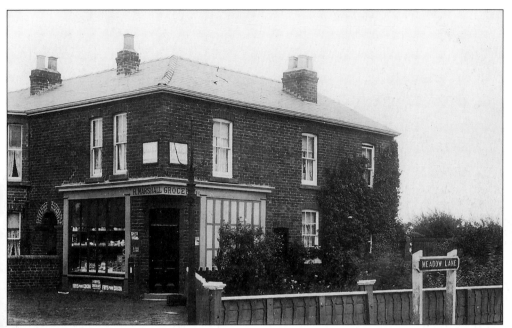

Marshall's corner shop, 797 Liverpool Road, 1914. When this photograph was taken the junction of Liverpool Road, Pinfold Lane and Meadow Lane was sometimes known as Four Lane Ends. Richard Marshall's business concentrated on groceries, tobacco and gardening.

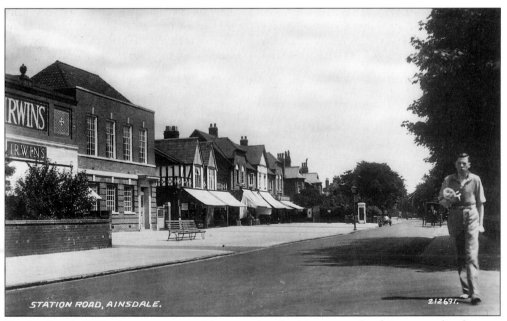

Station Road, 1931. A young man, with a towel under his arm, makes his way to the shore to bathe. Next to Irwins grocers is the Ainsdale telephone exchange, and also a range of shops and a post office, which supplied the needs of residents and visitors alike.

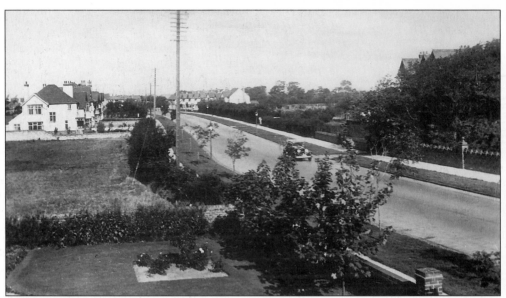

Liverpool Road, c. 1930. This view is taken from the elevation of Woodvale railway station, looking towards Birkdale. On the left are the newly-built houses to the south of Pinfold Lane, while on the right, unseen behind the decorative wall and trees, is the mansion known as Cavendish House, which at the time was a school for mentally handicapped children.

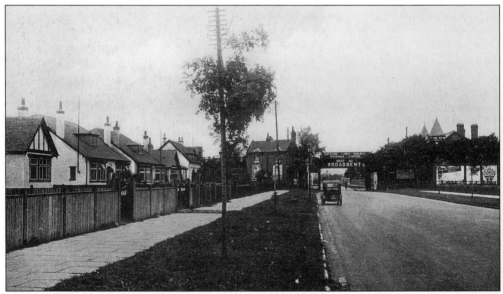

Liverpool Road, Woodvale, 1932. The next station en route to Liverpool from Ainsdale Beach was Woodvale. The station house stands alongside the bridge over Liverpool Road, with its prominent exhortation to shops at Broadbents. The conical turrets of Cavendish House are visible to the right, whilst on the left is the row of smart, newly-erected bungalows comprising the most southerly housing in the borough of Southport.